IMAGES
of *America*

DIGITAL EQUIPMENT
CORPORATION

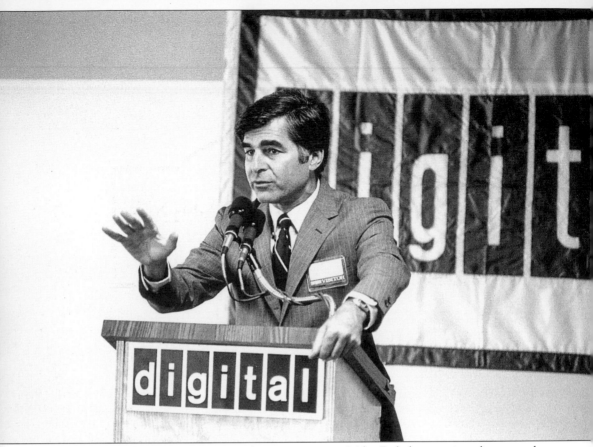

In his second administration, Massachusetts governor Mike Dukakis continued to pay plenty of attention to his state's most successful corporation, Digital Equipment Corporation (DEC), which by that time ranked as the number two maker of computers in the world. (Photograph by Karen McCarthy.)

IMAGES

of America

DIGITAL EQUIPMENT CORPORATION

Alan R. Earls

ARCADIA
PUBLISHING

Published by Arcadia Publishing
Charleston SC, Chicago IL, Portsmouth N 3 1712 01275 0769

Printed in the United States of America

Library of Congress Catalog Card Number: 2004102288

For all general information contact Arcadia Publishing at:
Telephone 843-853-2070
Fax 843-853-0044
E-mail sales@arcadiapublishing.com
For customer service and orders:
Toll-Free 1-888-313-2665

Visit us on the Internet at www.arcadiapublishing.com

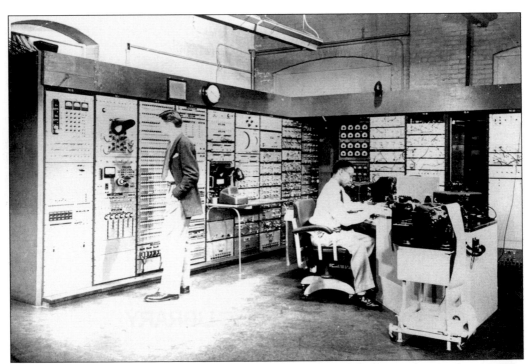

This is a view of the Whirlwind computer at MIT; the date and personnel are unknown. The Whirlwind project was begun near the end of World War II with the stated goal of creating a computer that could power a flight simulator. It was the first computer to pioneer interactive computing, and was a powerful influence on early computers that were created by DEC from the company's inception.

CONTENTS

ACKNOWLEDGMENTS

I am grateful for the help and assistance of many individuals in the research and preparation for this book. In particular, Ann Jenkins, a longtime assistant to Digital Equipment Corporation (DEC) founder Ken Olsen deserves thanks and praise for providing access to the collection of hundreds of images and documents over which she has stewardship. Indeed, unless otherwise noted, all of the images in this book were provided by her and Modular Services. Other images were generously provided by Alan Kotok, Rachel Berman, Reid Brown, Paul Delvy, Benn Schreiber, and my wife, Karen McCarthy.

Support or information also came from Gordon Bell, David Cutler, Reid Brown, the Digital Alumni Association (www.decalumni.com), and from informal alumni Web sites such as DEC Southern California, Digital Semiconductor Alumni, the Digital Workstations Group, and Richard Seltzer's Internet Business Group page.

In addition, the following books provided valuable information on Digital: *The Ultimate Entrepreneur* by Glenn Rifkin and George Harrar; *DEC is Dead, Long Live DEC: The Lasting Legacy of Digital Equipment Corporation* by Edgar H. Schein with Peter DeLisi, Paul Kampas, and Michael Sonduck; and *Digital at Work–Snapshots from the First 35 Years*, edited by Jamie Parker Pearson.

Finally, my editor, Kaia Motter, and the staff at Arcadia Publishing have, as always, been patient and imaginative. And, of course, special thanks go to Ken Olsen and the people of Digital for the creativity and energy they brought to the computer industry for so many years.

INTRODUCTION

This book, which I had thought to subtitle "The Computer Revolutionaries," is the result of a continued, long-term personal fascination with why and how innovation occurs, and in particular, why certain regions become centers of attraction for particular kinds of companies. In my previous Arcadia title, *Route 128 and the Birth of the Age of High Tech*, I provided a taste of the entrepreneurial culture and technical acumen that powered the growth of Greater Boston in the years after World War II and made it the first hotbed for high technology in the United States. Of course, no company was a greater embodiment of those times or a greater example of success than DEC.

The oft-told story begins with Kenneth Olsen and Harlan Anderson forsaking the relative security of MIT's Lincoln Laboratory for the hurly-burly world of starting a business. Aided by advice and a nearly penurious investment of $70,000, the pair launched a business success story that eventually propelled the company to second place (albeit a distant second) behind IBM, the ever-dominant force in the computer industry. The accomplishment led *Fortune* magazine to dub Olsen America's most successful entrepreneur in an October 1986 article.

But getting there took more than dumb luck. All of the founders were engineers, and just to write their business plan they had to lean heavily on the limited resources of the Lexington Public Library. Still, they had just the kind of moxie that Gen. Georges Doriot, the head of the pioneer venture capital fund American Research and Development (ARD), was seeking. He often stated that the men he backed were just as important, if not more so, than the ideas they proposed in a business plan. And his company was set up not only to make a profit but also to accomplish the social goal of getting good ideas out of the laboratory and into the U.S. economy. Despite some wariness about whether building computers could work as a business proposition, he took on the novices and pointed them in the right direction.

The result, of course, more than justified his confidence. In part, it was undoubtedly that DEC had the right idea at the right time. Government research and development budgets were growing, universities were expanding, and the potential of the computer was tantalizing to almost everyone. DEC broke down the barriers of cost and access that had made computers available to only the select few and changed attitudes about where, when, and how computers could be employed. Indeed, in one early application, a DEC computer was hauled into the field to help tabulate results from a skydiving competition—an unheard-of innovation at the time.

For individuals in Massachusetts who lived and grew up in its shadow, DEC was more than simply a successful business; it was a beacon of hope in a time of tumult and change. As the

traditional manufacturing businesses of the region faltered and failed, DEC bounded forward. Although DEC eclipsed many traditional companies, it kept a link with the region's past by maintaining its headquarters at the mill building of American Woolen, a once-famous wool processing facility in the area. DEC was launched there in 1957.

Digital was also the epitome of all that was new and exciting. Like many other people, I got my first hands-on exposure to computing through contact with a DEC product. In my case, as a high school student in a town not far from Maynard, I time-shared with students at a number of other high schools to compose my simple programs (written in FOCAL, a language developed by Bolt, Beranek & Newman, another pioneer tech firm). As I interacted one line at a time through the noisy teletype, I became part of a web—a community—that was already established globally.

That community of DEC users and DEC employees had a profound influence on the future of computing. The accomplishments of Digital are many and range from pioneering interactive computing to trailblazing a presence in cyberspace.

This book attempts to tell the story, primarily through photographs, of DEC and its great and continuing influence on the world of information technology.

One

AN IDEA AND
A COMPANY

DEC was founded with the help of $70,000 from General Doriot's ARD venture capital organization, which bought a 70 percent stake in the company. Ken Olsen and co-founder Harlan Anderson set up operations in 8,500 square feet of the old American Woolen mill building in Maynard, Massachusetts. Built on the success of its logic module products, Digital quickly became profitable.

The company moved to build complete computer systems, its original goal. Using DEC's first laboratory module products as building blocks, the Programmed Data Processor-1 (PDP-1) was designed by engineer Ben Gurley and became the world's first commercial interactive computer when it was introduced in 1960. This interactivity made it useful for a number of things, including the first experiments in time-sharing at MIT and the development there of the first video game, Spacewar! Itek, one of the leading high-tech companies of the time, purchased the second PDP-1 for use in electronic drafting, creating the world's first computer-aided design (CAD) application. The PDP-1s sold for about $120,000, far less than other commercial machines of the time. Some came with a display terminal—another computing first.

The Digital Equipment User Society (DECUS) that bound together the company's customers was launched in 1961 and grew to become the biggest single company user group in the world.

Although the PDP-2 and PDP-3 were proposed, they were never manufactured. The PDP-4 came to the market in 1962, and was priced at about half the cost of the PDP-1.

In 1963, the company announced the creation of the PDP-5—a development often described as the first of the minicomputers, based on its size and price, though it never sold in quantity. Then in 1964, the PDP-6, a 36-bit machine and the first relatively large machine from Digital, became available. It offered the first manufacturer-supported, time-sharing system available commercially, able to support up to 128 users simultaneously.

But the real beginning of the minicomputer—the product that, based on size, rock-bottom price, and success in the market, became synonymous with the company—was the PDP-8, which was introduced in 1965. It quickly captured the imagination of customers and became one of the key machines in Digital's history. It had a 12-bit word length, a 1.5 microsecond

9

cycle time, and a whopping 4K of primary memory. A teletype provided input-output. The price, which was several times that of a typical car, was $18,000. In 1966, the PDP-8/S, a serial version of the machine, was offered with 4K of memory for even less, about $10,000. The year 1966 also saw the introduction of the PDP-9, another 18-bit machine. It was roughly twice as powerful as the earlier PDP-7.

The pace of product introductions mirrored the rapid growth of the company. LINC-8, for example, also emerged in 1966. It was a machine designed by MIT's Lincoln Laboratory using the PDP-8 processor unit. The Laboratory Instrument Computer (LINC) was targeted at the medical and biological research market.

The late 1960s saw further variants of the PDP-8 introduced to the market, along with the LINC-based PDP-12, of which some 400 were sold. DEC's larger computers also prospered. The PDP-15 succeeded the PDP-9 and found favor in the physics and communications markets.

Meanwhile, the first public offering of Digital stock was made in 1966, and in 1968 the company was listed on the American Stock Exchange. Although DEC had grown dramatically, it still had a small-company feel. Olsen himself was known to drop in to the assembly or test areas at any time. Veterans recalled that people shifted from one job or function to another depending on the problems confronting the company on a given day. Often those problems simply revolved around getting the largely hand-wired machines to perform reliably and pass the diagnostic tests needed to make them customer-ready. In one case, a test engineer found that a spider was fulfilling the "bug" role and was moving in nightly, altering the functions of a clock timing circuit and repeatedly foiling attempts to get the machine to pass. To keep that problem from recurring, procedures for vacuuming components and cleaning the shop floor were instituted.

Despite the growth of the computer system side of things, modules remained an important business. As late as 1964, *Business Week* reported that they represented about half of the company's revenues.

The last of the 53 PDP-1s produced was made in 1969.

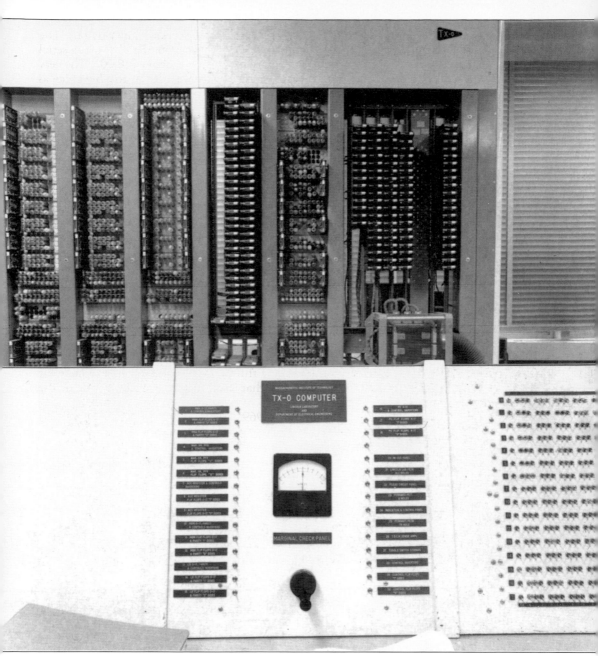

The TX-0, invariably referred to as TX-"Oh," was a second-generation MIT machine that proved to be very influential on DEC's future. For one thing, it used transistors rather than vacuum tubes.

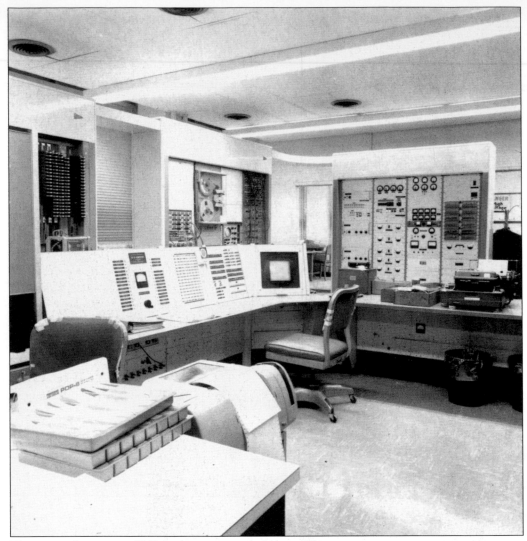

This is another view of TX-0, showing its whole control room.

This is a view of the back panel of TX-0. Many years after it went out of service at MIT, TX-0 was laboriously restarted at the Computer Museum when that organization was first launched under DEC's rubric using facilities at Marlborough's MRO-2 building.

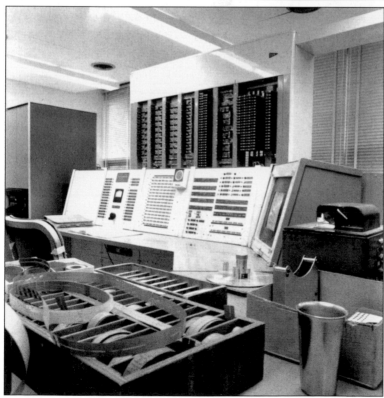

The TX-0 is shown here with a telltale rack of punch tape in the foreground.

Ken Olsen looks both young and earnest in this 1959 company publicity shot.

THIS INDENTURE made this 27ᵗʰ day of August, 1957,
between MAYNARD INDUSTRIES, INC., a corporation organized
under the laws of the Commonwealth of Massachusetts (herein-
after called the Lessor) and DIGITAL EQUIPMENT CORPORATION, a
corporation organized under the laws of said Commonwealth,
(hereinafter called the Lessee).

W I T N E S S E T H:

The Lessor does hereby demise and let unto the
Lessee the following described premises, to wit:

The Second floor of Building No. 12 of the so
called Assabet Mills, formerly owned by the American
Woolen Company in Maynard, Massachusetts, excepting
and reserving therefrom the halls, stairways, shaft-
ways, pipeways serving other parts of said build-
ing, and the Lessor reserves the right to maintain,
use, repair and replace pipes, ducts, wires,
meters, and any other equipment, machinery, apparatus
or fixtures serving the demised premises or other
parts of said building. Said leased space to
be approximately eight thousand six hundred (8,600)
square feet. The Lessee shall have the right
to use in common with the Lessor and its other
tenants the common hall and stairways located
in, and the driveways serving said building, so
far as may be reasonably necessary for ingress
and egress.

Said premises are to be used and occupied for
the purpose of research, development and manu-
facturing of electronic equipment.

TO HAVE AND TO HOLD said premises, with the
appurtenances thereunto belonging, unto said Lessee for a
term beginning with the first day of September, 1957 and
ending at the expiration of the thirty-first day of August,
1959.

YIELDING AND PAYING therefor during the term
aforesaid the sum of THREE THOUSAND SIX HUNDRED ($3,600.00)
DOLLARS per year, payable in equal monthly installments of
THREE HUNDRED ($300.00) DOLLARS commencing on the first day
of September, 1957 and thereafter on the first day of each
and every month, in advance, during said term.

This is a copy of the original lease agreement for space at Building 12 of the American Woolen complex in Maynard, Massachusetts.

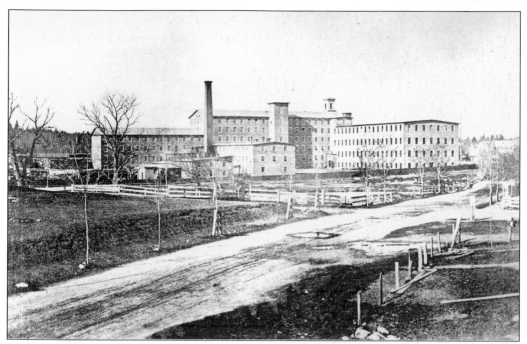

This is a 19th-century view of the American Woolen plant.

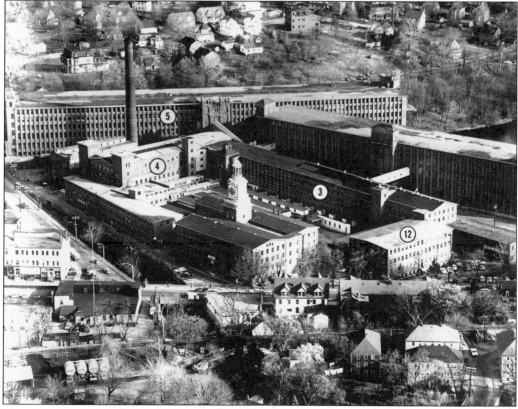

The size and complexity of the mill complex is on display in this c. 1960 aerial view.

The Assabet River, which made the creation of the American Woolen Mill possible, is in the center of this image. Years of industrial pollution took a toll on the river, and it is still recovering. For the most part, the shift to higher technology lessened the strain on the river, and well-heeled suburbanites, many of whom were employed by DEC and its competitors, were often active in cleanup efforts.

This is an undated view of the mill complex with construction activity in progress. Note the debris and the caisson in the foreground.

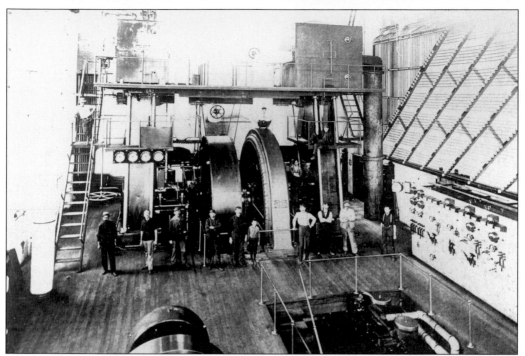

The modern power plant control room at the American Woolen Maynard plant, shown here in the early 20th century, is proof of how the original mill outgrew waterpower alone.

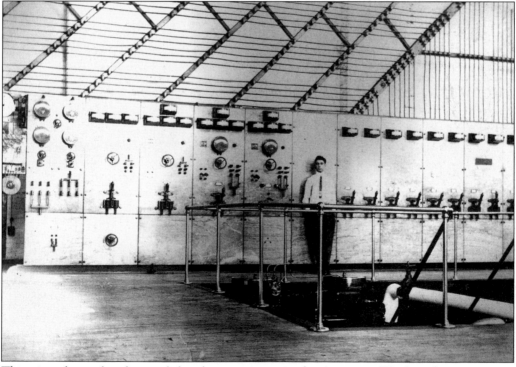

This view shows the electrical distribution system in the American Woolen plant—a circuit board writ large and undoubtedly high-tech for its time.

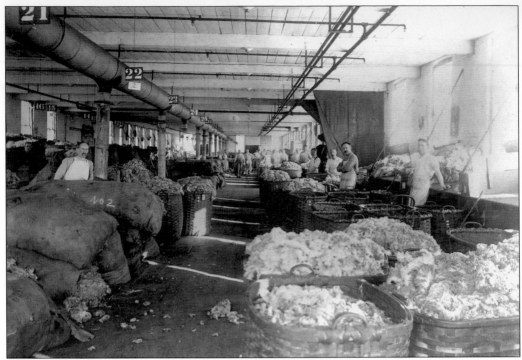

The raw material of the American Woolen operation was wool. Lanolin, the natural oil found in wool, eventually leaked from bales like these and saturated the wood floors. It continued to drip down on people and objects below well into the Digital era.

NOTICE.

Proof of **INTOXICATION** of any operative in the employ of this Company, will be sufficient cause for immediate discharge.

March 11, 1879. L. MAYNARD, Supt.

Morality and personal responsibility were emphasized for 19th-century mill employees in this poster. Compare this to the early DEC memo seen on the next page.

THOUGHT YOU MIGHT APPRECIATE IT.

Stan

__DIGITAL EQUIPMENT CORPORATION__

Maynard, Massachusetts

Subject: Telephone Calls

To: All Personnel

From: Stanley C. Olsen

Date: April 28, 1958

 The telephone bill for the month of March for Digital
Equipment Corporation came to $176.42. This is a large telephone
bill for a small company. It is suggested that employees minimize
long distance phone calls, and those that are made should be kept
as short as possible. A phone call to Boston costs 33¢ for the
first 3 minutes and 10¢ for each minute thereafter. This means
that a 20 minute phone call costs the company $2.20. It costs
17¢ to put a three minute call to Lexington.

 It is assumed that all employees will pay for personal
out of town calls. Miss Pontz will take payment for these calls.
For expensive calls like those to Boston, one might do well to
ask the operator to keep track of the charges.

Signed _Stanley C. Olsen_
 Stanley C. Olsen

Approved _Harlan E. Anderson_
 Harlan E. Anderson

SCO/jef

_Stan -
Have been cleaning out
Bob Lassen's files - times have
changed, haven't they?_

 To Kelly

This memo, signed by Olsen's brother, Stan, who held various positions with DEC, speaks of "doing the right thing," a company mantra. In this case, the right thing is to not waste company money on personal telephone calls. Of course, thanks in part to DEC's technology, which was widely adopted by the telecom industry, the cost of phone calls eventually dropped significantly.

What is DIGITAL TEST EQUIPMENT

DEC Digital Test Equipment is a coordinated set of fully transistorized 5 megacycle digital computer circuits packaged in a convenient and flexible Building Block form. They are used for testing and developing digital systems and components. All logical signals are available on the graphic front panels of the units, while the standard power connections are made from the back. Logical interconnections are made with patch cords using miniature stacking banana jacks. They are useful in any electronic laboratory or engineering department which uses or develops digital computers or special purpose digital devices. Their flexibility and reusability in many different applications make them an economical investment that will save engineering time and money. They will operate at temperatures up to 120°F without any cooling required.

DIGITAL TEST EQUIPMENT **Standard Signals**

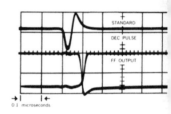

All models of DEC Building Blocks use the same three power voltages (-3v, -15v and $+10$v), thus allowing any arrangement of building blocks in the mounting panel. Power connections permit convenient marginal checking. The STANDARD DEC PULSE is -2.5 volts in amplitude and 70 millimicroseconds or less in width. The STANDARD DEC LEVELS are ground and -3 volts. These levels are used for all logical operations. The SPECIAL PURPOSE MODELS provide signal compatibility with other types of digital circuits.

Logical operations with DIGITAL TEST EQUIPMENT

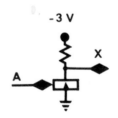

In DEC Building Blocks, logical operations are performed by combinations of saturable transistor inverters. The user can consider these as simple switches. In the graphic symbology used in DEC Building Blocks, a negative level on the input A (base of the transistor inverter) will "short" the output X (collector) to ground, while a ground level on A will open the gate and the output will be -3 volts. "And" circuits and "or" circuits are formed by putting transistors in series or in parallel. A DEC Flip-Flop is set by "shorting" the appropriate input to ground through a pulse gate. Diodes are used for logical operations in Model 110.

DIGITAL TEST EQUIPMENT **is economical too**

DEC Building Blocks save valuable engineering time because of the ease with which custom test equipment and logic can be assembled. Their general purpose design and versatility coupled with their high speed mean that they will be useful in a wide variety of applications for years to come. Their rugged construction and reliable operation will keep maintenance costs at a minimum.

This reproduction of two pages in Digital's first product catalog provides a brief description of

SUMMARY OF CHARACTERISTICS

MODEL	DESCRIPTION	INPUT	OUTPUT	QUANTITY DISCOUNT PRICE *	UNIT PRICE
INVERTER 103	Six transistor inverters for use as pulse gates and/or level gates.	Standard Levels Standard Pulses	Standard Levels (Will drive four or more level gates) Pulse gate will drive a F. F., Delay, etc.	$107.35	$113.00 ea.
DIODE 110	Two 6 input "negative or" circuits with output amplifiers.	Standard Levels	Standard Levels (Will drive four or more level gates.)	84.55	89.00
FLIP-FLOP 201	Five megacycle flip-flop with output amplifiers, indicator and two general purpose inverters. Generates carry pulse for counting.	From pulse gates	Standard Levels (Will drive ten or more level gates) Carry Pulse (Will drive one pulse gate)	123.50	130.00
DELAY 301	Pulse delay from 0.25 to 500 microseconds with a negative level during the delay and a Standard Pulse at the end of the delay.	Standard Pulse	Standard Pulse (Will drive ten pulse gates) Level output will drive eight or more level gates.	139.65	147.00
CLOCK 401	Variable frequency (500 cycles to 5 megacycle) oscillator with pulse output. Lower frequencies by use of external capacitance.		Standard Pulse (Will drive ten pulse gates)	139.65	147.00
PULSE AMPLIFIER 601	Will amplify and standardize pulses in width and amplitude. Contains a separate inverter.	Standard Pulse	Standard Pulse (Will drive sixteen pulse gates)	95.00	100.00
PULSE GENERATOR 410	Will generate Standard Pulses from push button or external signal such as oscillator, relay or switch contacts, etc.	Choice	Standard Pulse (Will drive ten pulse gates)	109.25	115.00
TUBE PULSER 650	Provides positive or negative pulses suitable for use with vacuum tube circuits. Contains a separate inverter.	Standard DEC Pulses	15 volt 0.1 microsecond pulse	$99.75	105.00
LEVEL AMPLIFIER 666	Provides compatibility between DEC Standard Levels and other digital circuits including vacuum tube types.	Standard DEC Levels	Ground and −15 volts	99.75	105.00
RELAY 801	Contains mechanical relay driven by a transistor amplifier. Used to operate mechanical counters, alarms, etc.	Standard DEC Levels	SPDT Relay Contacts (Up to 2 amperes)	84.55	89.00

See Instruction Sheets for Detailed Loading Specifications

ACCESSORIES

		QUANTITY DISCOUNT PRICE *	UNIT PRICE
POWER SUPPLY 721	Supplies standard three DEC voltages of −3v, −15v and +10v for a typical assortment of 45 DEC Building Blocks.	289.75	305.00
POWER CABLE 750	Molded cable with matching plug for Model 901 Mounting Panel.	2.85	3.00 ea.
MOUNTING PANEL 901	Will hold nine DEC Building Blocks, has built in filters, and can be used in rack or on bench.	95.00	100.00
PATCH CORDS 911	Miniature stacking banana jacks. Come in color coded lengths of 2, 4, 8, 16, and 32 inches in bundles of ten.	8.55/ten	9.00/ten

An inventory of all DEC Building Blocks shown is maintained at the Digital Equipment Corporation factory in Maynard, Massachusetts. Normally, shipments are made from inventory. All shipments are f.o.b. Maynard. Prices do not include state or local taxes and are subject to change without notice.

* *Quantity Discount Price: If an individual order on a unit price basis totals $20,000 or over, a 5% discount is applicable to the order. Prices effective November 1, 1958.*

the items that launched the company off the ground.

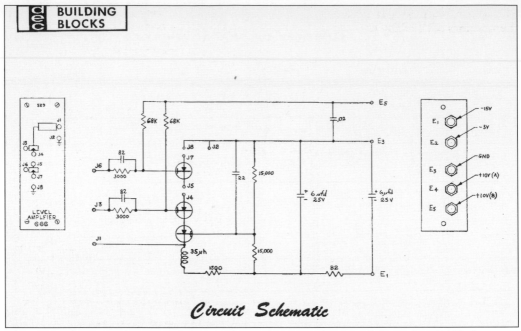

Circuit Schematic

This is a schematic for one of the products that was the initial basis for DEC's business. These simple circuits, packaged as modules, were created in response to an early trend in miniaturization. Transistorized, they were capable of being interconnected more flexibly than would have been possible with similar tube-based circuits and offered the potential for a building-block approach to electronic systems.

The manual for the PDP-1 had a grand total of 39 pages.

This system block diagram shows the workings of the PDP-1.

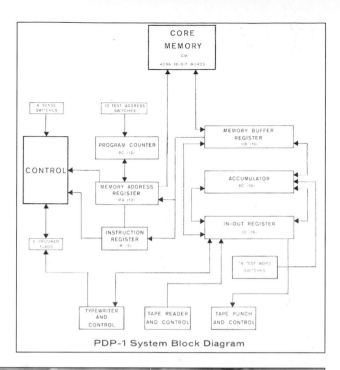

PDP-1 System Block Diagram

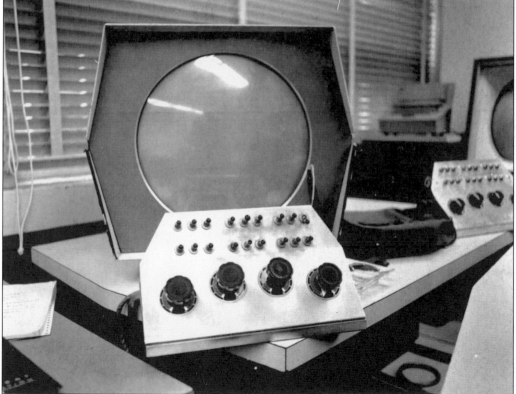

A DEC monitor—the familiar shape of which later became the basis for the logo of the Digital Equipment User Society (DECUS)—is shown in this view.

This illustration seemed to say that there is room at the top. Indeed, from the earliest days, DEC beckoned to the ambitious and provided room for many careers to grow. Over time, the company eventually became a good place for women and minorities to work as well, not just white males.

HELPFUL INFORMATION

An illustration for the employee handbook makes light of the navigational difficulties imposed by operations that were scattered around the sprawling mill complex.

This photograph shows a display of modules for trade shows. It was built by Display Workshops of Hartford, Connecticut.

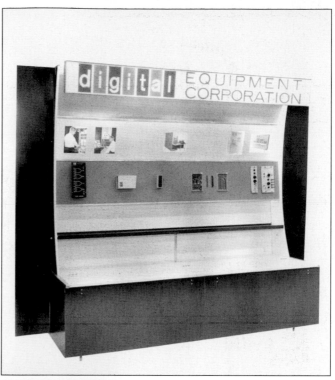

Perhaps the first of the company's handbooks, this early 1960s effort laid down the rules and regulations and also discussed career opportunities.

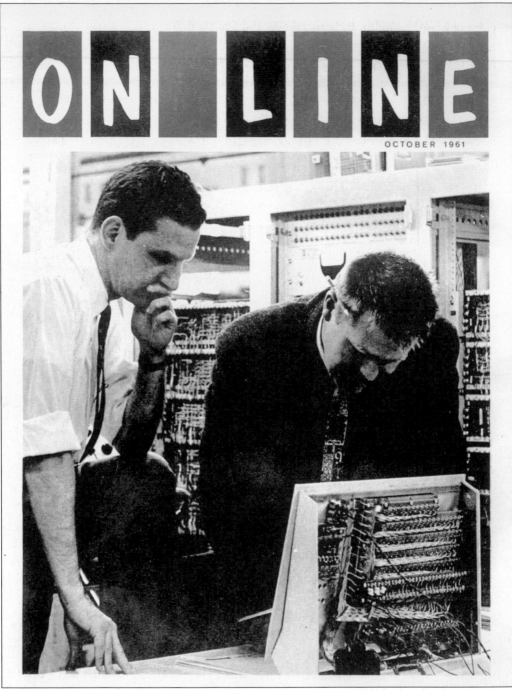

ON LINE

OCTOBER 1961

This company newsletter from October 1961 included a memo from Harlan E. Anderson about the importance of the customer and a recap of company growth since 1957. By this date, the company had grown from 8,500 square feet to 75,000 square feet and claimed to be doing business in 31 states plus the District of Columbia, Japan, Switzerland, and Western Europe. The company's recent sales success at a trade show in Toronto was credited, in part, to an unidentified Miss Digital.

26

ON LINE

AUGUST 1963

DIGITAL EQUIPMENT CORPORATION · MAYNARD, MASSACHUSETTS

ANNUAL OUTING SET FOR SEPT. 14

Camp Ararat in Maynard is again bracing for its annual invasion by Digital. On September 14, an expected 1100 persons, under the banner of "Company Outing", will gather at Ararat for a day of fun, food and friendliness.

They will not be disappointed, as a look at the following plans scheduled by the indicated committee heads will confirm. Activities will get underway at 12 noon or so.

Arrangements for food and refreshments for the outing are in Bob Lassen's hands, with John Tobin of Digital's cafeteria supplying the fare.

Joan Merrick and Paul Gadaire are organizing adult athletics. Plans include horseshoes, volleyball, badminton, and other activities. Softball is scheduled for the morning, up to 12 noon, and for after 5:00 P.M. This is necessary so the ball field will be available for the larger numbers of people who participate in contests and games.

Entertainment for children and adults is being arranged by a well qualified quartet – Jack O'Connell, Mary Ellen McHugh, Jack Grieve, and Dave Hamilton. Arrangements include hayrides, cartoon shows, dancing in the evening, and a few surprise activities to be unveiled on the 14th. (Continued on Page 2)

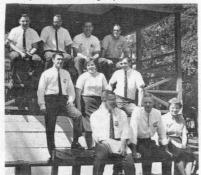

Part of the Company Outing Committee recently made a reconnaisance trip to Camp Ararat to map out strategy. Front row, left to right, Bob Lassen, Ken Pierce, Mary Colombo. Middle row, Don Watson, Joan Merrick, Dave Hamilton. Back row, Mort Ruderman, Jack O'Connell, Paul Gadaire, Jack Grieve.

PDP-5 IS EXHIBITED FOR FIRST TIME

Left to right, Ed DeCastro, Don White, and Mel Arsenault give last-minute checkout to the PDP-5 before shipping it to WESCON.

The new Programmed Data Processor-5 computer was exhibited for the first time at the Western Electronic Show and Convention (WESCON) in San Francisco, August 20-23. It was demonstrating a unique computer application by acting as a pulse height analyzer. PDP-5 was recording and displaying the gamma ray energy levels given off by a radioactive cobalt sample.

Using the PDP-5 for pulse height analysis offers greater flexibility than wired-program, special purpose analyzers, since it can handle numerous computation tasks when pulse height experiments are not being run. And the computer eliminates the tasks, and possible errors, of copying numbers from counters onto data sheets and plotting a spectrum curve point-by-point. Instead, the experimenter directly observes the spectrum as it forms on the Cathode Ray Tube Display Type 34.

When the pulse height experiment is completed, the program prints and punches out all the values needed to reconstitute the spectrum for post-mortem analysis by the

(See Page 2 – More Trade Show Activity)

A future competitor of DEC's, engineer Ed DeCastro, who went on to launch and lead Data General Corporation, is shown on the cover of this 1963 issue of *On Line*. He is visible in the upper left of the top photograph, along with Don White and Mel Arsenault, preparing a PDP-5 for shipment to the Western Electronic Show and Convention. Another article talked up the company outing and showed a children's pie-eating contest from the year before, while a back page photograph showcased early plant-floor automation in the form of a punch-tape- controlled Bridgeport milling machine.

DIGITAL AT THE IEEE SHOW...
efforts of many produced a successful showing

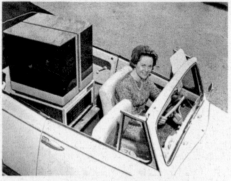

To show that our PDP-8 is truly a compact computer, it was photographed on the back seat of a VW convertible. The picture was sent to newspapers in Boston and NYC to announce the first exhibit of the PDP-8 at the IEEE Show. Karen Eriksen of Sales is at the wheel. The new Volkswagen was supplied by Mr. Paul W. Carey of Hansen-MacPhee Engineering Co., Inc. of Waltham, New England Distributor for VW.

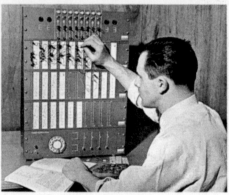

Bill Colburn is shown operating the new Digital Laboratory System which was introduced at the IEEE Show. Bill is demonstrating how dozens of different, basic logic circuits can be made by changing simple front panel connections.

Digital's participation at the Institute of Electrical and Electronic Engineers (IEEE) International Convention and Show called on the efforts of many people from many departments. Their efforts--on the homefront and at the show--produced the professionalism that characterized our IEEE Show exhibit.

Held on March 22-26, it was the largest electronics show ever, and exhibits filled the Coliseum in New York City and spilled over into the New York Hilton Hotel. The hotel also hosted the many technical sessions that were held each day.

Digital had a 30-foot exhibit booth. With a new gold-color carpet and dark wood back paneling, it showed-off our equipment very effectively.

We featured the PDP-8. It was the first time exhibit of the new computer, and three of the machines were in the booth. One was operating and demonstrating programs, another was up on a pedestal at the edge of the booth to allow show-goers to examine it closely, the third was mounted in a cabinet. The PDP-8s attracted much attention and our booth personnel had their hands full telling people about the computer.

Our new Digital Laboratory System was introduced at the show. It is a versatile digital-logic training device and design tool. A desk-top unit, it allows designers or students to build an operating digital system--complete with logic elements, power supply, controls, indicators, and mounting hardware. By changing simple front panel connections, dozens of different, basic logic circuits can be made. The system is built around our FLIP CHIP Modules.

As a training device, students, technicians, and engineers can learn all basic digital logic techniques. A workbook containing detailed experiments in 2 and 3 hour lab sessions will be included with the system.

As a design tool, engineers can breadboard their designs on the new system, experimenting with different configurations for optimum system performance. The lab system can also be used in simulation and testing. For example, it can simulate a computer to test input-output devices, or a memory control to check out arithmetic processors.

A section of the booth featured FLIP CHIP Modules since they form the basic building blocks of the PDP-8 and the Digital Laboratory System. A glass-topped display case contained samples of FLIP CHIPs in various stages of construction as well as finished circuits.

(Continued on page 3.)

While the miniskirt took London's Carnaby Street fashion scene by storm, this 1965 publicity shot on the cover of *On Line* showed just how small a PDP-8 minicomputer was. Karen Eriksen of the sales department is at the wheel of the Volkswagen convertible.

The 1965 annual report boasted the company's progress in selling the PDP-6 time-sharing computer. Eight were in service at the time. Meanwhile, the PDP-7, a faster version of the PDP-4, was selling at the rate of seven to eight per month, and the LINC, a machine designed by MIT's Lincoln Laboratory, was also being manufactured, primarily for biomedical applications. Thirty-nine of these machines, built from DEC modules, were in service.

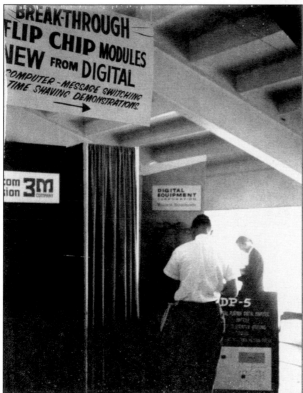

It's showtime! A Polaroid snapshot of a mid-1960s Digital trade show booth touts both Flip Chip modules and the PDP-5.

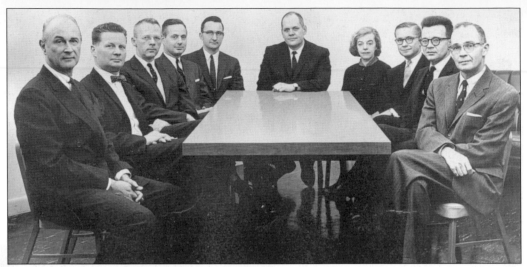

This is a photograph of an early board of directors. Shown, from left to right, are the following: Henry W. Hoagland, vice president of American Research and Development (ARD); John Barnard Jr., general counsel of Massachusetts Investors Trust; Jay W. Forrester, professor at the School of Industrial Management, MIT; William H. Congleton, vice president of ARD; Harlan E. Anderson, vice president of DEC; Ken Olsen; Dorothy E. Rowe, treasurer of ARD; Vernon R. Alden, president of Ohio University; Arnaud de Vitry; and Wayne P. Brobeck, director of consumer relations for Vitro Corporation of America.

Harlan E. Anderson, DEC's vice president and a company cofounder, is shown with Mark Hahn of Evansville, Indiana, at the ARD meeting on March 3, 1965. The nature of the conversation is not on record.

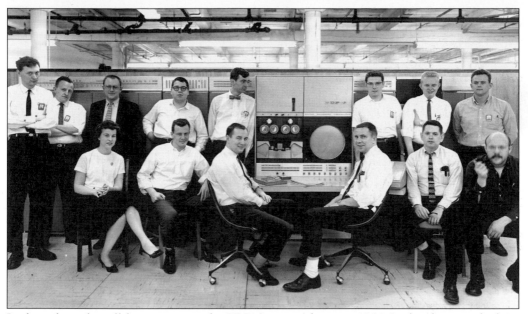

In this relatively well-known image, the PDP-6 team is shown *c.* 1964. In the photograph, from left to right, are the following: (standing) Peter Samson, Leo Gossell, Gordon Bell, Alan Kotok, Russ Doane, Bill Kellicker, Bob Reed, and George Vogelsgang; (seated) Lydia McKalip, Bill Coburn, Ken Senior, Ken Fitzgerald, Norman Hurst, and Harris Hyman. (Photograph courtesy of Alan Kotok.)

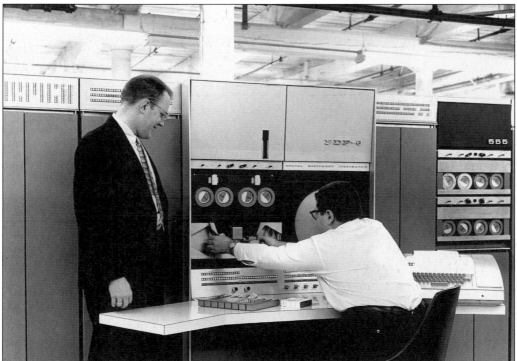

Here is a view of the console of a PDP-6 *c.* 1964. Alan Kotok is trying to feed paper tape while Gordon Bell looks on. (Photograph courtesy of Alan Kotok.)

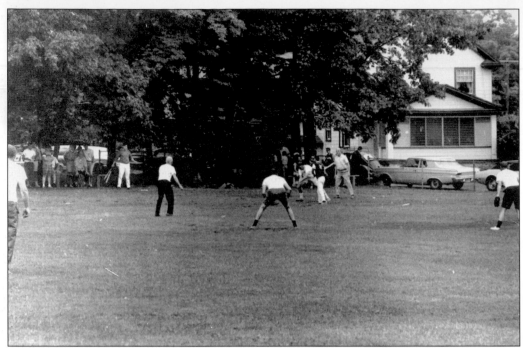

This view from the outfield shows a company softball game on July 10, 1968.

Here, Ken Olsen watches the action from the bullpen.

Rained out, team members and supporters huddle under shelter during a sudden downpour.

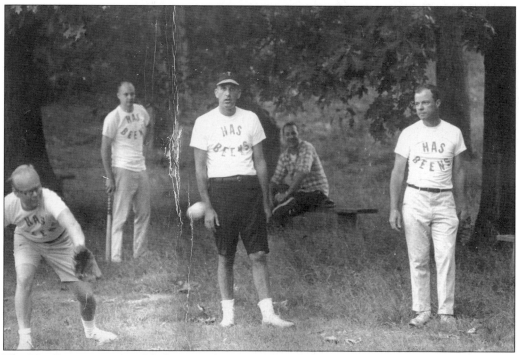

The Has Beens was an unlikely name for a team from such a prominent technical company.

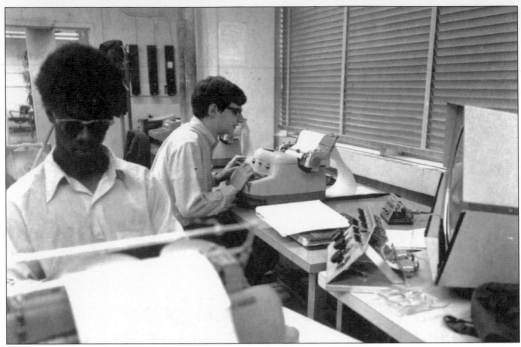

The PDP-1 and subsequent DEC products introduced a generation of computer programmers to the art of coding. A distinctive DEC monitor can be seen at the right of this image.

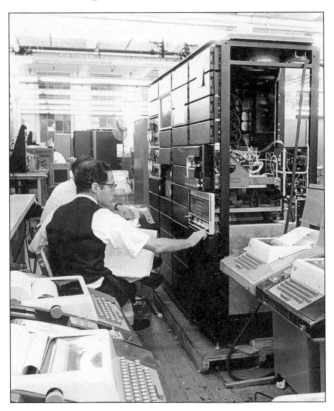

Mill operations involved not only manufacturing products but also testing and debugging them. In this c. 1965 view, engineers are running diagnostics on a PDP-8. Short-sleeved white shirts were proper summer attire for engineers before air conditioning became universal.

Two

THE MINICOMPUTER ERA BEGINS

The fortunes of the minicomputer waxed (mostly) and waned (occasionally) from the 1960s to the 1980s. For much of this time, the companies in the field, with DEC usually in the lead, represented the most exciting developments in computing. To be sure, IBM and its lesser imitators marked many accomplishments in the mainframe environment, but the increasing ubiquity of minicomputers, which moved from their early presence in science and engineering to growing popularity in the business world, signaled something profound and new and foreshadowed the impact the PC would have in later years.

In 1974, the company celebrated several milestones. It shipped its 30,000th computer system, purchased the Maynard mill complex in its entirety, introduced its first microprocessor, and earned a ranking in the Fortune 500, placing at 475. Within a year, another 20,000 computer systems had been shipped. As one executive commented, the company's biggest problem was hiring more people and setting up more facilities.

And there were plenty of new facilities. In addition to those opened overseas, a manufacturing plant was added in Springfield, Massachusetts, and a disk drive plant in Mountain View, California, in 1970. Then in 1972 came plants in Westfield and Westminster, Massachusetts, as well as the new Parker Street facility in Maynard. The RCA manufacturing facilities in Marlborough, Massachusetts, were added to the roster in 1973, followed by Burlington, Vermont, in 1976, Merrimack, New Hampshire, in 1977, and Colorado Springs, Colorado, and Tewksbury, Massachusetts, in 1978.

Digital even built its own magnetic core manufacturing facility, which was producing cores at the rate of 30 billion a year by the mid-1970s.

Annual sales hit $188 million in 1972, when the company had 7,800 employees. In 1977, sales topped $1 billion, and the company had 36,000 employees.

The biggest news of the period on the business side was DEC's debut on the New York Stock Exchange, a sign that the company had truly arrived.

Meanwhile, a new product, the PDP-11, was selling like nothing before. It was built on a 16-bit architecture rather than the 12 bits used in the hot-selling PDP-8, and special thought was given to creating a design that could endure for more than a few years. After some false

starts, and with competing 16-bit machines already available from competitors, an engineering team in the mill raced to complete the design. The PDP-11 featured a new UNIBUS architecture—a single bus structure for connection to all of the system components. Also, in a departure from most previous practice, it was built of custom-made circuit boards rather than preexisting modules, which allowed it to be reduced to half of its originally anticipated size.

The first PDP-11, the PDP-11/20, began shipping in 1970. Over the course of the product's long life, which extended into the 1990s, more than 600,000 PDP-11s were sold. Later versions incorporating advances in microprocessors (specifically, the LSI-11) were made possible in part by Digital's own semiconductor manufacturing arm. The PDP-11/70 was at the high end of the product line and was the first in the series to use cache memory.

In other news, Digital got involved in the growing office automation market with DECmate, a word processor. Perhaps even more significant, the VT100 terminal set the standard for the computer industry and became the market standard, often sold for use with computer systems made by competitors. Another Digital first was the establishment of remote computer diagnostic capabilities in Colorado Springs.

The KI10, one of Digital's large computers, became the first 36-bit machine to incorporate integrated circuits. It played a cameo role in the futuristic George Lucas film *THX1138*.

Meanwhile, progress was being made in networking. Inspired perhaps by the Department of Defense–funded Advanced Research Projects Agency Net (ARPANET), which was a forerunner of the Internet, and by IBM's development of a method for connecting mainframes, Digital pioneered DECnet, which soon became one of the most advanced computer communication technologies available. Of even greater long-term significance, in 1980 Digital, Intel, and Xerox agreed to cooperate in the development of Ethernet networking.

Intriguing "might have beens" dot this period, including the establishment of a retail computer store by DEC in Manchester, New Hampshire, and the small-scale production in the late 1970s of the Programmable Data Terminal (PDT)—a personal computer by another name. Former DEC programmer Dan Bricklin initially eyed the PDT as the vehicle on which to build VisiCalc, the pioneer spreadsheet application that ultimately ended up putting the Apple II on the map and jump-started the PC revolution.

Growth did occur at DEC, despite some serious problems. The company had developed several distinct and mutually incompatible product lines, including the PDP-8, the PDP-11, and the PDP-10 series. Even peripherals were manufactured separately.

But DEC's breakneck growth and its creative "do your own thing" culture, while continuing to spawn creative products, also threatened to undermine the company's future. Most publicly, the company embraced a form of matrix management instead of the usual top-down hierarchy. Individuals often reported horizontally to peers and vertically to more than one department. These arrangements changed with regularity. When it worked well, it seemed to produce energizing results that attracted the attention of management pundits. But its potential to sap the organization of strength was also becoming manifest—nothing much could get done at Digital without buy-in from lots of people and many, many meetings.

When DEC veteran Gordon Bell returned from a stint at Carnegie-Mellon University to become head of engineering in the early 1970s, he began to break down the fiefdoms and enforced a degree of standardization across the enterprise. It was an effort that had some success, but autonomy had become part of the fabric of the corporation.

This photograph shows Olsen and others waiting for the market reaction to Digital's first day as a publicly traded stock.

Olsen and Anderson are shown here, probably at an early 1960s ARD meeting.

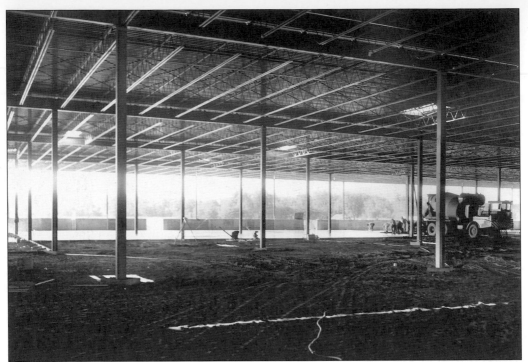

This is a *c*. 1969 photograph of the Westfield plant under construction.

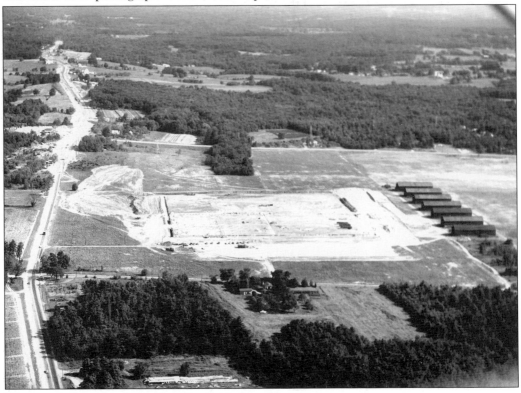

This aerial view also shows the Westfield plant site.

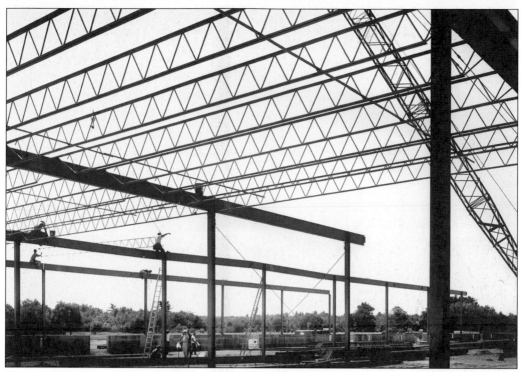

Here, ironworkers prepare the frame of the Westfield building.

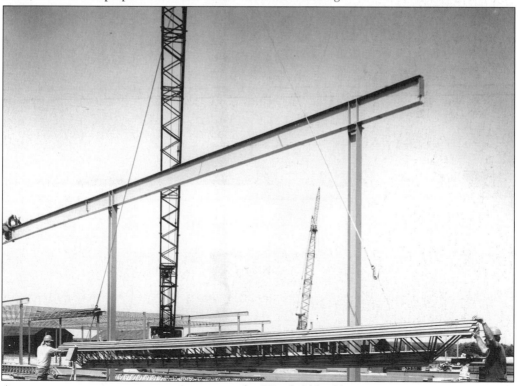

A crane prepares to position roof trusses in the Westfield building.

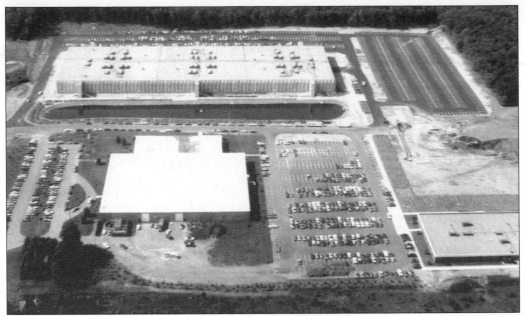

The new Maynard plant, located about a mile from the mill, is shown in this 1973 aerial view.

There is plenty of time for Sargents, at least if they are governors. As Digital grew more successful, the political leadership of Massachusetts paid even more attention. In this photograph from September 13, 1973, Olsen and Digital were saluted for their business success by Gov. Frank Sargent.

DEC hosted the governor's arrival for a tour of the new Maynard facility.

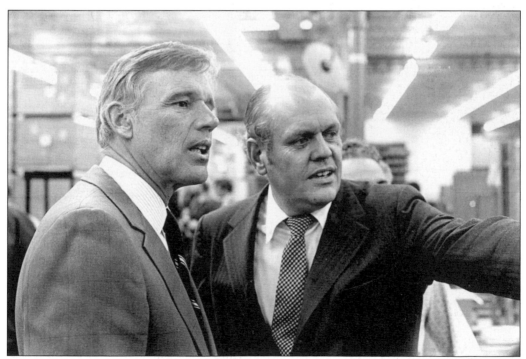

In his own element, Olsen proudly showcased his company's facilities.

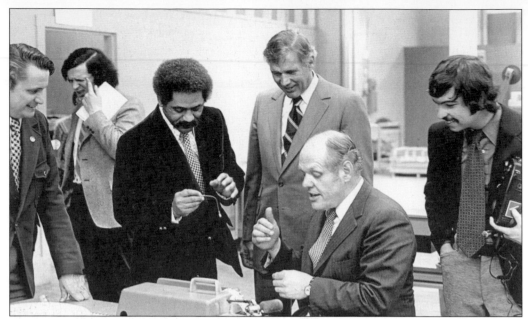

Olsen was always ready to roll up his sleeves. Here, he explains a manufacturing process to Governor Sargent.

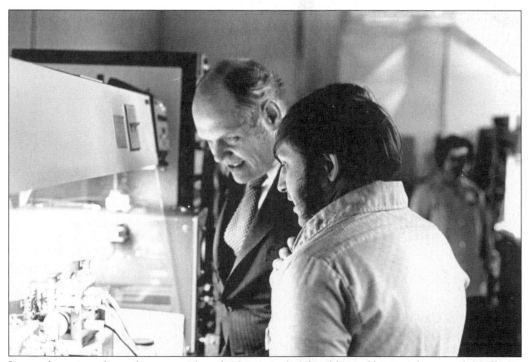

In another view from the tour, Olsen looks over the shoulders of his employees—literally, in this case.

Here is yet another gubernatorial photograph opportunity, this one at John Hancock Hall in Boston. At that time, the governor proclaimed Massachusetts to be "the Minicomputer State."

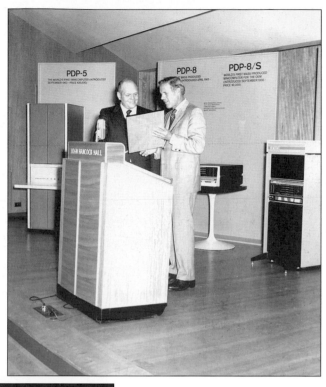

Maynard Salutes
Digital Equipment Corporation

APPRECIATION NIGHT

November 30, 1971
Maynard High School Auditorium
8 p.m.

The same gubernatorial proclamation also designated Maynard as "the Minicomputer Capital of the World." Shown here is the cover of the program for the celebrations, which coincided with the centennial of Maynard's incorporation as a town. Later, in the 1980s, the town increased its attention to Digital by declaring a Ken Olsen Day, complete with a parade through the downtown.

This is an undated scene from a trade show.

Here, Olsen is shown in flight. The occasion is unknown, but perhaps he was scouting out a new plant location.

Olsen is seen here with a group of co-op students in 1974 in an unknown location.

Ken Olsen is shown here with son Jim during a 1972 company outing.

Two Shoe Firms Closing,
650 Workers Jobless

Two more major shoe firms in the Brockton area have announced plans to phase out operations as the demise of New England shoe plants continued.

(Continued on Page Nine)

THE VOICE OF
Page Four
S.B.A.N.E.
SMALL BUSINESS

BAY STATE BUSINESS WORLD
INCLUDING THE 128 WORLD

VOL. VII NO. 11 JANUARY 20, 1971 Published Every Wednesday PRICE FIFTEEN CENTS

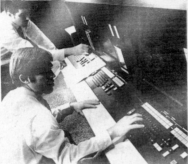

PROCESS CONTROL SYSTEM — The operator's console, featuring both alphanumeric and graphic capabilities, of the new computer control system, FOX I, introduced by The Foxboro Co., Foxboro, is shown above. The system is designed specifically for process control and plant monitoring and features a breadth of technical innovations and advances in hardware and software. The new system consists of five major elements: application-oriented software; a central processing unit; a unique CRT-based operator/engineer console; input/output equipment; and a full peripheral complement.

Olsen Of DEC Named
'70's Top Businessman

By ANDREW M. MONAHAN

Kenneth H. Olsen, president and founder of Digital Equipment Corp., Maynard, has been named Bay State Businessman of the Year for 1970 by the World.

Much happened last year in the computer industry, both locally and nationally, and Olsen represents the best talent that was visible among an executive group of top caliber.

"Olsen has done a good job in a tough year, and a tremendous job for many good years," said last year's top Bay State Businessman, Herbert Roth, president of LFE Corp., Waltham. This briefly summarizes the record that has been slowly growing for 13 years and has put Olsen's firm in a dominant position in the field of minicomputers.

1970 was a year of exceptional activity in the computer industry, capped by a major merger, and the addition of another major main frame producer to the Massachusetts industrial scene. RCA announced in November a major expansion of its Marlboro facilities which would add 3,000 jobs and place the headquarters of another top computer firm in the state on Route 495.

Unquestionably, the business transaction of the year in the industry was the merger of Honeywell and General Electric into a new firm guided by Honeywell

as the majority stockholder. At the head of this new firm and deeply involved in creating a strong, profitable main frame producer is Clarence Spangle.

(Continued on Page Seven)

2 Major Deals
Lead '70 News

Two major business transactions, each complex, deserve special attention in any review aimed at selecting the Businessman of the Year.

The merger of the Honeywell and General Electric computer manufacturing operations and the final resolution of Boston's football stadium problem rank with the major deals of any year.

Honeywell Information Systems (HIS), formed by the Honeywell-GE merger, has sales of over $800 million and employs about 50,000 people in plants and offices in 50 countries.

At the center of this colossal operation, second to giant IBM is Clarence W. Spangle, a senior vice president of Honeywell and chief operating officer of HIS, which controls 81.5 per cent of the new firm.

(Continued on Page Six)

Tourism Good Field
For Creative Minds

This Week The World is publishing Part II of a three-part series on tourism opportunities in Massachusetts. Of particular interest as potential business ventures, this week's article focuses on potential tourist attractions throughout the state .

This is excerpted from Report No. 2, Tourism and Its Development Potential in Massachusetts (Summary Report), prepared by Bulent I. Kastarlak, planning and design consultant, and published by the Massachusetts Dept. of Commerce and Development in December 1970.

The analyses of over four thousand tourist attraction in Massachusetts suggests that attractions do not follow a rigid locational pattern and, most important, they can be created at any place about almost anything. Given the theme idea and resources, new attractions can be built or organized in areas where they could stimulate the growth of the tourism industry. A proper mix of attraction could generate a large variety of supporting facilities in an area, thus allowing the tourists to find more opportunities to spend their money.

As illustrations of potential attractions in Massachusetts, the following are recommended:

- "Technology Park" — a museum of technological discoveries which have taken place in Massachusetts.
- "Footwear and Leather Museum" reflecting the leadership role of the Commonwealth in leather product industries.
- "Space Museum" — depository of Prof. Goddard's memorabilia and center for historical research.
- "Massachusetts Trade Center — permanent exhibit of Massachusetts industries and trades.
- "Freedom Center" — reflecting the meaning of democracy.
- "Center for Pre-School Education" — exhibits depicting the learning process.
- "Center for Performing Arts" — School, museum and a forum for the performing arts.
- "Bicycle Tour of Massachusetts" — An interrelated system of bicycle paths, tours, tournaments.
- "Fly-in" — A new resort community combining the airplane with land and sea attractions.
- "Dude Farm Chain" — resorts presenting opportunities for a way of life fast disappearing in Massachusetts.
- "Maritime Park" — reflecting Massachusetts past and future roles in worldwide maritime commerce and shipbuilding.

(Continued on Page Ten)

═══ EDITORIAL ═══

Reflections on Selecting
The Top 1970 Businessman

Selecting the top Bay State businessman of 1970 or any year involves a lot of input of facts and figures from many people, but probably the eventual choice is symbolic. Many exceptional executives wrote an impressive record in what was a dismal year of 1970.

As the state becomes more oriented towards services than manufacturing, attention is attracted toward men in fields of finance, marketing, distribution, education and medicine. A number of leaders deserve special attention as they founded or led companies in non-government supported industries and dramatized "conversion" as practical.

1970 saw Massachusetts become a major center of the huge computer industry. Only a few years ago one daily newspaper bemoaned the fact that this state had lost the race to establish a computer industry. This industry means so much to the future prosperity of all in the region that extra attention must be given to it.

The men in the computer industry must be a bit taller than others because of the size of the market and the amount of dollars involved. We have them here in Massachusetts — some in the same league such as Olsen. Since the choice tends to be necessarily involved with the present, we must pause to reflect on the lead-

(Continued on Page Six)

The Bay State BUSINESS WORLD is published weekly except for the week before Christmas and the first and third weeks in July by the 128 Publishing Co. Inc., 80 Walpole Street, Norwood, Mass. 02062. Subscription rates: $3 one year; $5 two years, and $7 three years. Second Class postage paid at Norwood, Mass. 02062.

In the midst of a sharp and prolonged regional economic downturn led by cutbacks in defense spending and the shuttering of old textile and shoe businesses, DEC and Olsen increasingly represented salvation for the Massachusetts economy. In 1970, Andrew Monahan, publisher of *Route 128 World* and *Bay State Business*, declared Olsen to be the Bay State businessman of the year. This front page also includes a news item about the loss of 650 jobs at two Massachusetts shoe manufacturers.

What was putting the grim look on Olsen's face during this shop floor visit?

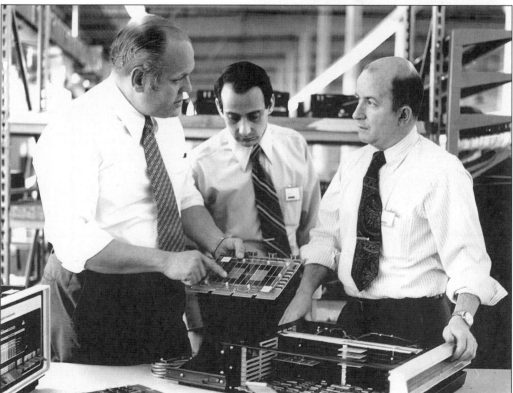

Whatever the cause was, it appears to be getting resolved in consultation with an unidentified manager and Andy Knowles. Knowles, an RCA veteran, led the creation of the PDP-11. He left Digital in 1983 as vice president of marketing.

DEC acquired property rapidly through the 1970s and 1980s.

This is an exterior shot of the Merrimack, New Hampshire, facility.

Ken, wearing a hard hat, is caught here on a visit to the Merrimack facility while it was under construction in May 1977.

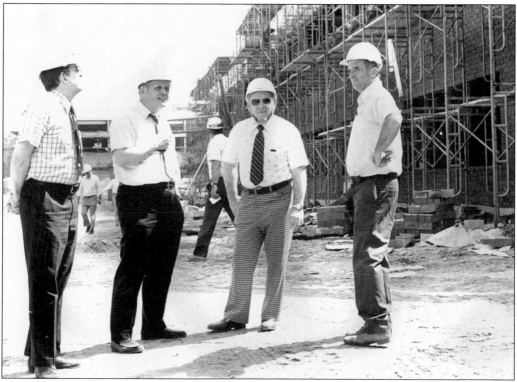

Ken is shown again on-site in Merrimack. Note the bearded man to the right of Olsen wearing the plaid trousers, which were at the height of 1970s fashion.

The Merrimack plant is shown here as it neared completion.

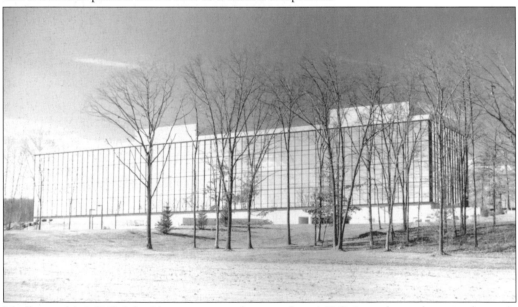

Marlborough's MRO-2 building, sister to the sprawling MRO-1, is shown here in the early 1970s. The complex was originally home to RCA's computer operation, and it later housed various manufacturing, engineering, and administrative functions for DEC. The MRO-2 building was also the first home to the Computer Museum.

This photograph shows testing of the PDP-11/05. The versatile PDP-11 line was eventually produced in the hundreds of thousands and was a key component in building the company's fortunes.

This is a view of the assembly line in the mill for the PDP-11/05.

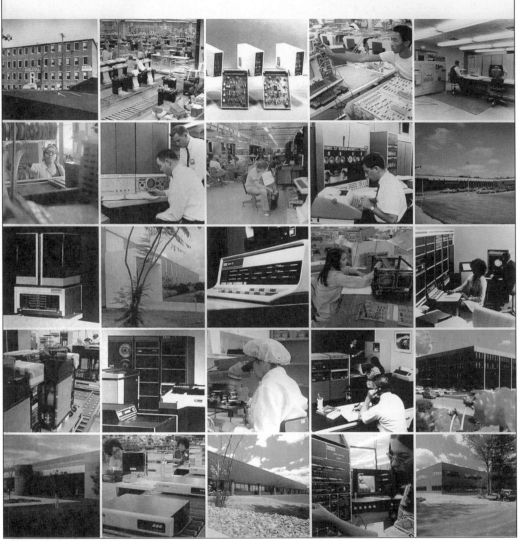

The 1977 annual report marked the company's first revenue exceeding $1 billion, while research and development spending rose 35 percent to $80 million annually.

The Boston plant is shown here under construction. DEC was hailed at the time for its commitment to bring jobs to the inner city.

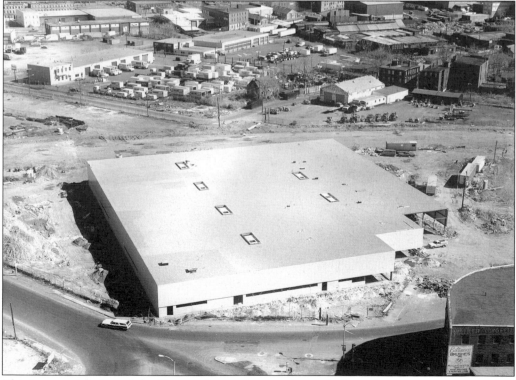

This is an aerial view of the Boston plant as it neared completion.

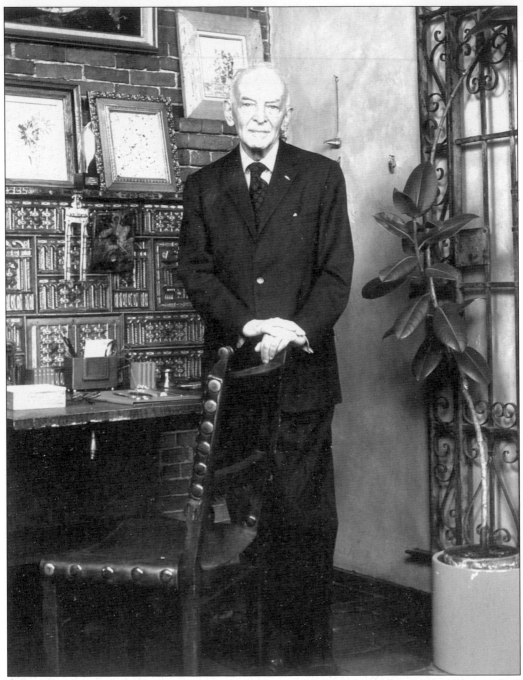

This formal portrait of General Doriot, *c.* the early 1980s, shows him at his Beacon Hill (Boston) home. Doriot remained an active voice in the company until his death in 1987.

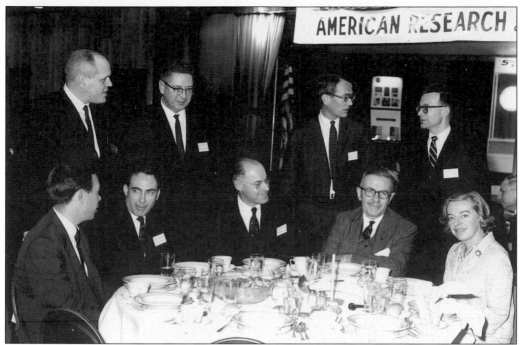

Here is a snapshot of the 1966 ARD annual meeting. Pictured, from left to right, are the following: (standing) Ken Olsen; William Wood of Applied Dynamics; William Barnabas McHenry of *Reader's Digest*; and Arnaud DeVitry of EED; (seated) David Dyche of Morgan Guaranty; Jim Busby of Optical Scanning Corporation; Dwight P. Robinson Sr., a director at ARD; Capt. Joseph Jeffery, CEO and director of ARD; and Dorothy E. Rowe of ARD.

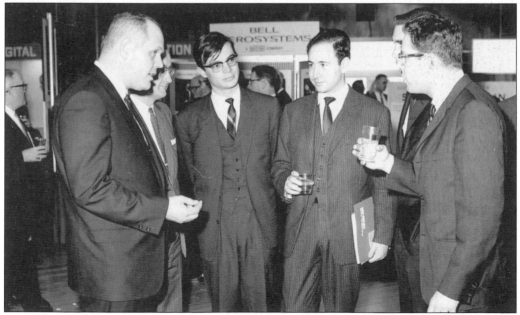

This view of the 1965 ARD annual meeting shows, from left to right, the following: Ken Olsen, DEC vice president Harlan Anderson, and Harvard Business School students Geoffroy deVitry, J. P. Lehman, Steven Popell, and Tom Widdoes.

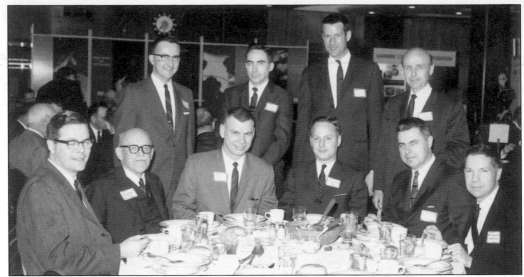

Another photograph from the ARD annual meeting of 1965 shows, from left to right, the following: (standing) Harlan Anderson; John Busby, president of Digitek Corporation; James Stockwell, vice president at Adage Inc.; and Dr. Cuthbert Hurd, chairman of computer usage; (seated) Richard Close of Airborne Instruments Laboratories; Ralph E. Flanders, Vermont senator and ARD director; Lloyd Hahn, president of Hahn Inc.; William Congleton of ARD; R. J. Bailey, vice president of Autoclave Engineers; and Jack Hamilton, vice president of Geotechnical Corporation.

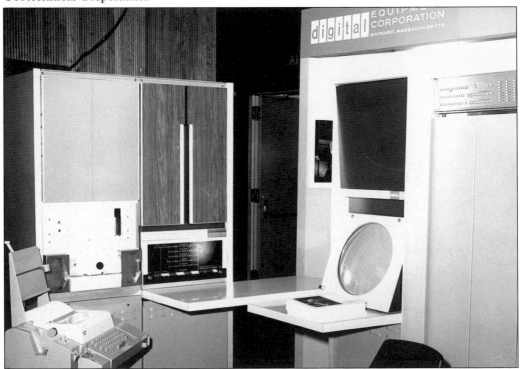

ARD meetings doubled as small-scale trade shows. This photograph shows the DEC display at the 1966 ARD annual meeting.

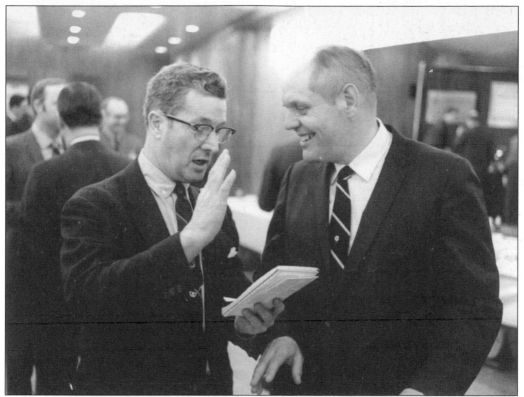

In this image, Olsen fields a question from Lester Smith of the *Wall Street Journal* at the 1970 ARD annual meeting.

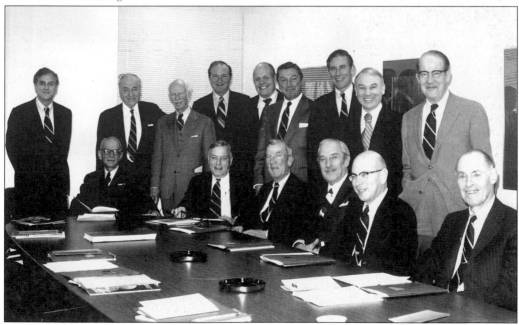

At the 1975 ARD annual meeting, General Doriot is seated at the head of the table. Olsen is in the middle of the standees.

At a press conference in Hudson in November 1976, DEC vice president Edward Schwartz is shown with Olsen and Massachusetts governor Mike Dukakis. The event may have had to do with plans to extend an access road from Interstate 290 to a DEC semiconductor plant.

Another view of the same Hudson press event shows, from left to right, the following: (first row) transportation secretary Fred Salvucci; Olsen; Hudson official Argeo Cellucci Jr. (father of future governor Paul Cellucci); Dukakis; Howard Smith of the Hudson board of selectmen; and unidentified; (second row) Marlborough mayor Frank Kelleher; commissioner of commerce and development John Marino (a former high-tech entrepreneur who founded a company called Memory Technology); an unidentified person who was deputy commissioner in the department of public works; commissioner of the department of public works John Carroll; and unidentified.

Three

BUILDING A
GLOBAL BUSINESS

Digital wasn't just a fast-growing company; it was a fast-growing international company. From DEC's earliest years, global sales were an increasingly important share of total revenues. Although still housed in very modest quarters within the mill, DEC opened a sales office with three employees in Munich in 1963. Canadian manufacturing operations began near Ottawa the next year and in Reading, England, in 1967, a year when corporate revenue reached $38 million.

From there, things progressed rapidly. Manufacturing operations were up and running in San German, Puerto Rico, in 1968, and sales and service operations were located in 11 countries. Small-scale manufacturing of PDP-8s began in Reading, too.

In 1971, with European operations now headquartered in Geneva, manufacturing operations began in Galway in the Republic of Ireland. That growth spurt was followed by a plant in Kanata, Ontario, in 1972, a core memory plant in Hong Kong in 1973, and another manufacturing facility in Puerto Rico at Aguadilla.

The mid-1970s saw the opening of manufacturing facilities in Ayr, Scotland, Kaufbeuren, West Germany, and Clonmel, Republic of Ireland. In the early 1980s, a manufacturing operation was added in Singapore and a research and development operation was added in Tokyo.

Digital at Work, a company history, profiled the importance of two of these facilities to the company's success. San German began operations in 1969 with just 29 employees and a focus on producing components for the PDP-8. In keeping with a pattern that DEC often followed in the United States and elsewhere, San German was located away from the more industrialized region of the island. Indeed, DEC executive Peter Kaufman said he recalled agonizing briefly over whether putting a plant in the midst of the beautiful fields of western Puerto Rico was the right thing to do. But the region had a large, capable labor pool and the plant would provide tax benefits to DEC. The decision was made, and the facility was completed and operational in less than a year.

The decision to hire so few people initially, despite the company's desperate need for more manufacturing capacity, came from a corporate goal of creating a high degree of

local autonomy—but not until a core group of employees had acquired a full dose of Digital culture.

A few years later, when a sister plant was completed 40 miles away in Aguadilla, the Puerto Rican operations had 2,000 employees and, for a time, comprised of 25 percent of the company's total manufacturing capacity.

Meanwhile, the need to begin manufacturing in Europe was being driven by the sting of high tariffs imposed on products without at least half of their value added in Europe. Although the Common Market, the predecessor to the current European Union, had yet to approve the Republic of Ireland as a member, DEC began to look there for a low-cost production facility. They found the right place in Galway, along the wind-swept coast of the west. In 1971, DEC set up a substantial manufacturing facility there to produce PDP-8 and PDP-11 systems for Europe. In fact, Galway became one of the most completely integrated operations in the company, manufacturing everything from circuit modules to CPUs to printers.

Digital was rewarded for its effort when Ireland gained Common Market membership and the plant was certified as meeting the value-added requirements.

Significantly, overseas plants were not relegated to handling secondary operations. Puerto Rico was given a pioneering role in developing environmental controls to clean up manufacturing processes, and the APT system, which automated part of the diagnostic process on completed machines, was first tried there before being implemented stateside.

At each of the sites, the impact of Digital's culture was profound. In one company story, a Frenchman described the difficulty he initially faced in accommodating himself to the lack of hierarchy, the openness, and the informality of Digital's operations. Having made the transition, however, he declared he would never be able to work for a French company again.

In both of these instances and in others, Digital strongly supported local institutions, particularly universities. Digital brought such an improvement in technical education that other companies began to look to the same areas to locate their facilities. The Galway plant even boasted one of the largest computers in Ireland (a PDP-10), which made the place seem all the more interesting to technically inclined people. Indeed, in the case of Galway and other later European operations, the plant itself became an important sales tool in the regional market.

Of course, Digital's rise as a global company wasn't without problems. Language barriers and differing national approaches to problem solving could make accomplishing shared goals a challenge. In one anecdote, the managers in Reading, England, complained that their newest facility was too small. They were scolded by Maynard for failing to realize it had been entirely up to them to decide how big it should be.

Then there was the larger question of how much autonomy and bottom-line responsibility should be granted to overseas operations. Europe, which represented a huge portion of corporate revenues, began to press for greater control in the 1970s, a call that was long resisted by Maynard.

DEC eventually came to describe itself as a leading worldwide supplier of networked computer systems, software, and services. Indeed, by the 1990s, Digital did more than half of its business outside the United States, developing and manufacturing products and providing customer services in the Americas, Europe, Asia, and the Pacific Rim.

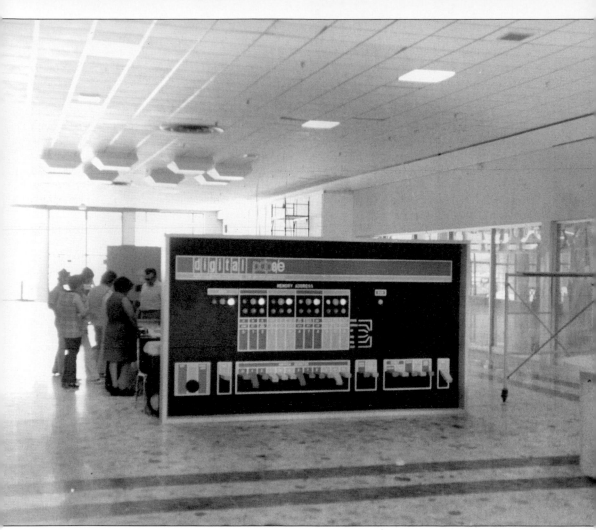

Workers for the new Puerto Rico plant are interviewed beside a large mockup of a PDP-8 control panel.

Here, a worker prepares to cast a concrete column around a bundle of reinforcing bars for the Puerto Rico plant.

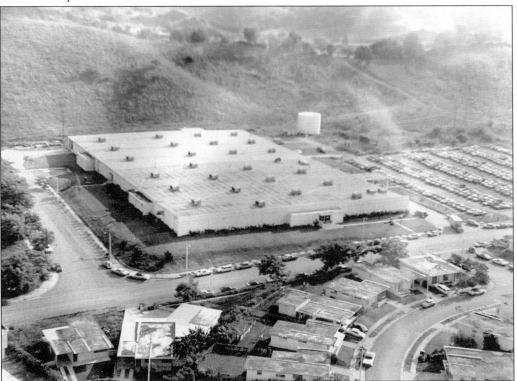

This aerial view shows the finished Puerto Rico plant.

Another view shows the lush countryside near the Puerto Rico plant.

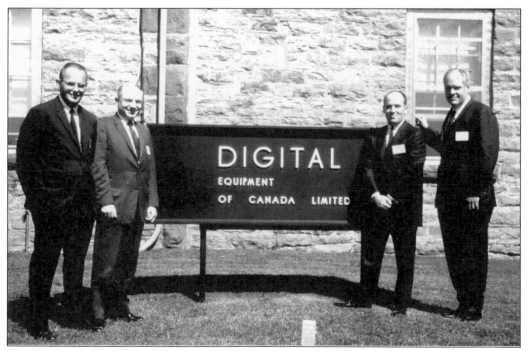

Olsen, standing at the far right, is shown paying a visit to DEC of Canada.

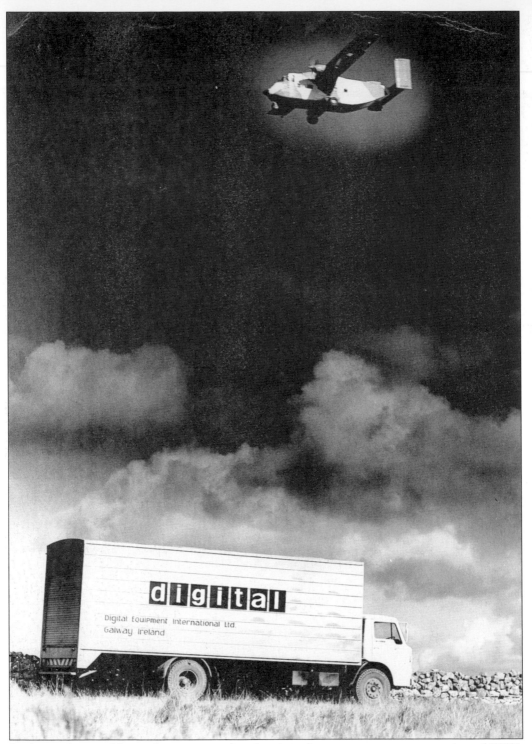

In this striking publicity shot, apparently related to the construction or expansion of DEC's Galway plant in the Republic of Ireland, a short-takeoff-and-landing aircraft, manufactured by Shorts Brothers, flies overhead.

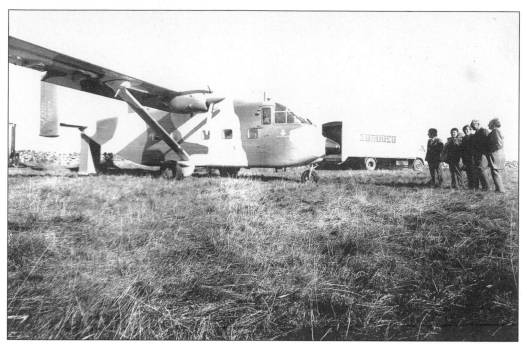

On the ground, the same short-takeoff-and-landing aircraft shown in the previous shot is shown with some of its passengers.

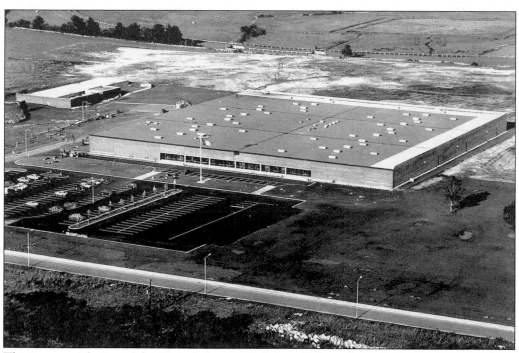

This is an aerial view of the Digital plant in Ballybrit, Galway, Ireland. The author toured the facility in 1987 and was particularly impressed with the robotic materials-handling vehicles, which were state-of-the-art at the time.

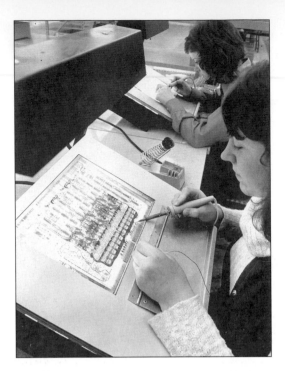

This image shows the debugging of computer circuit boards at the Galway facility.

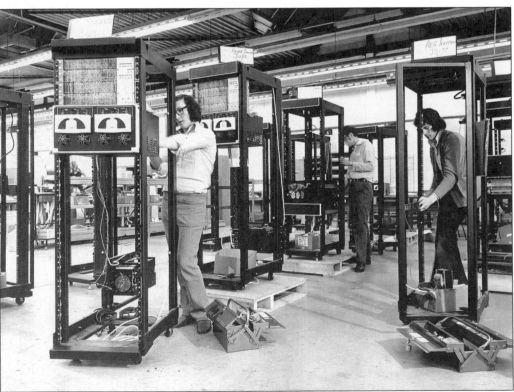

Power wiring and assembling computer cabinets was also done in the computer systems area at Galway.

Module boards are being inspected under a magnifying glass in this view of the Galway operations.

The inspection of the quality of soldered computer modules from a wave soldering machine was another important task.

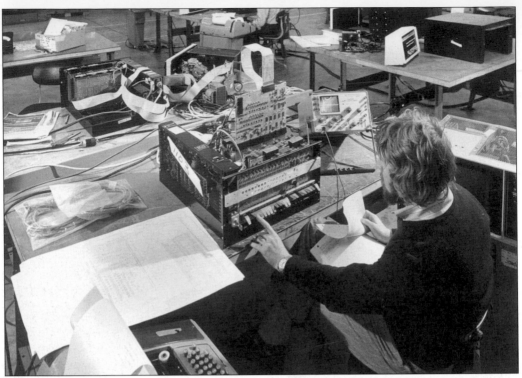

Even the debugging of computer processors was handled at Galway's computer test area.

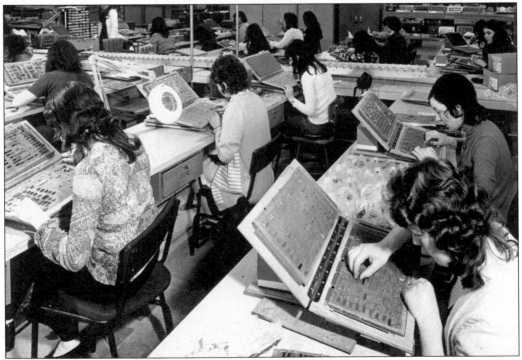

This view from Galway shows workers inserting electronic components in computer module circuit boards.

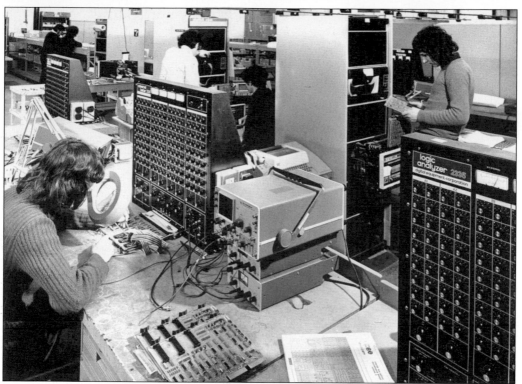

Another processing detail shows the soldering of computer modules in the module assembly area.

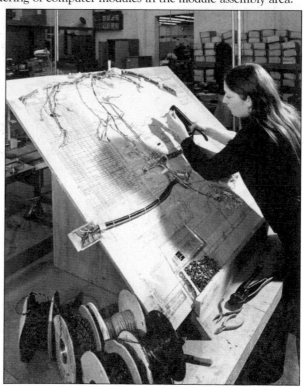

In this view, an employee assembles a computer system harness at the Galway facility.

This is one of a series of screen shots from DEC in Reading, England, probably from the 1970s. The original image is in color and shows off the capabilities of the VT-30.

Here, in another VT-30 image, bar graphs are displayed for a presumably mythical company, Waterloo Informatics & Piano Tuning Company. Again, the original images are in color.

Perhaps these election results are also for demonstration purposes only.

The VT-30 was able to draw these vectors, in the days before "what you see is what you get" (WYSIWYG) and high-resolution graphics, using only eight special characters.

The VT-30 also pioneered the idea of the engineering workstation by supporting graphics such as this functional diagram.

An additional dimension to DEC's overseas expansion is shown in the series of photographs from 1981 of Japanese employees being indoctrinated. Here, T. Kato, personnel manager, speaks at the Aburatsubo Recruit Center.

Ed Reilly, seen standing behind the man with the microphone, and other visitors from corporate headquarters are introduced to the Japanese recruits.

Here, education committee members stand in front of the Aburatsubo Recruit Center.

In this shot, T. Kato explains DEC's philosophy to recruits.

Here, uniformed recruits are conducting morning exercise. Clearly, life at Aburatsubo was a far cry from the more laid-back corporate culture of stateside Digital.

And if calisthenics weren't enough, new employees followed that with a good run.

In this shot, trainees learn the "basic manner" required at the workplace.

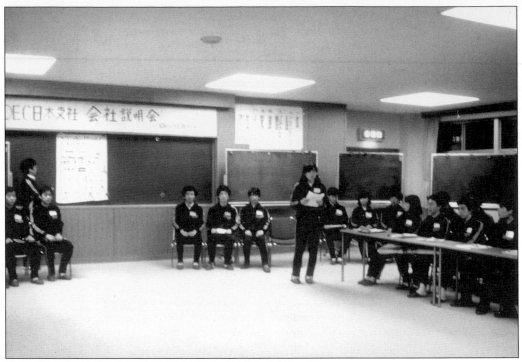

Here, new graduates give a presentation on Digital.

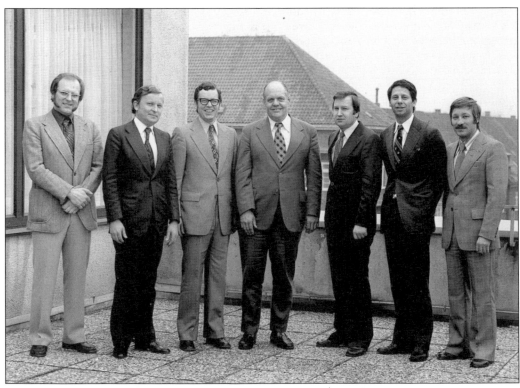

Olsen is shown here with German employees in Hannover in 1974.

Four

THE MINI GIANT

Although the PDP-11 architecture remained very popular, it was running into an inherent problem: its limited address space. Technically, while there was some possibility of stretching the PDP-11, many thought the best option would be a move towards a totally new architecture. This would have meant potentially walking away from the company's most successful product and a huge customer base. The solution that emerged, the Virtual Address Extension (VAX), stepped up from 16 bits to 32 bits and doubled general registers from 8 to 16. But the key to VAX was that memory space did not have to be in the system's internal memory all at the same time; it could reside on a disk until a specific piece of information was needed.

The VAX concept is generally ascribed to Gordon Bell, while the engineering team on the project included the likes of Bill Demmer, Larry Portner, and Bill Strecker. Significantly, the original design was set up to fully incorporate the PDP-11, thereby ensuring customers of a potential migration path.

The VAX-11/780 was introduced in 1977 and quickly established itself as an industry milestone. At almost the same moment, Digital shipped its 100,000th computer system; that figure was to double in only two more years. Only three years later, in 1980, the VAX-11/750 debuted; it was the first minicomputer built on large scale integration (LSI) chips.

On the business side of the ledger, the company added facilities in Boston, Massachusetts, Tempe, Arizona, and Nashua, New Hampshire, and revenues topped $3 billion in 1981.

As Digital grew, its unique matrix management structure and increasingly wide-ranging geography presented challenges. For instance, in the early 1980s, DECwest was established in Washington State, largely as a vehicle to keep software star Dave Cutler at Digital, according to veteran Reid Brown. Cutler had a string of successful software products at DEC, including the operating systems RSX-11A, RSX-11M, and VAX/VMS, as well as a PL/1 compiler.

After considering Thunder Systems, a West Coast software startup, and interviewing at Intel, Cutler approached Gordon Bell, Digital vice president of engineering, to see whether Digital might be able to provide a solution to his frustrations. According to Reid Brown, Bell said he would sponsor a remote engineering facility anywhere, but he wanted it to be near a university with a first-class computer science program. The Seattle area won due to the presence of the University of Washington's Computer Science Department, its friendliness to business, and its natural environment. DECwest was born.

DECwest started in a two-story office building on 116th Avenue in Bellevue in the summer of 1981. The original DECwest charter was to produce software for chip-based VAX systems.

The first DECwest product, the VAXEln real-time operating system, released in 1983, met that goal. But the DECwest charter quickly expanded to include hardware due to schedule and cost problems with the first VLSI VAX system (Scorpio).

Reasoning that part of the problem with putting VAX on a chip was the complexity of the VAX architecture, Cutler and several senior engineers, including Dick Hustvedt, Rich Witek, and Bob Supnik, proposed a smaller subset of the VAX architecture that would be easier and faster to implement in silicon: the MicroVAX. "Dave further proposed that he build the first MicroVAX system [MicroVAX I] at DECwest using discrete logic in order to get a product to market quickly," explained Brown, "and Hudson [MA] undertook the single chip implementation." The resulting MicroVAX family of products moved the VAX into new markets and dramatically increased corporate revenues through the mid-1980s.

After MicroVAX, Cutler and his team were ready for bigger things, and they proposed doing a follow-on architecture to VAX that was based on the Reduced Instruction Set Computer (RISC). There were several RISC projects going on in the company at that time, and it was widely assumed in the industry that it was only a matter of time before RISC architectures overtook Complex Instruction Set Computer (CISC) architectures such as VAX. After a year of proposals and counter-proposals, DECwest was finally given the responsibility for the new RISC architecture, known as Parallel Reduced Instruction Set Machine and code named PRISM.

DECwest moved in 1986 to its present location on 24th Street in Bellevue, with a new charter to define the PRISM architecture and design operating systems and computer hardware to implement it. Hiring began in earnest for hardware and software engineers, and at its height, DECwest employed over 200 engineers, all working on various aspects of PRISM.

Unfortunately, PRISM was perceived as a threat to the still-profitable VAX, which led to significant corporate resistance. The result, according to Cutler, was that the PRISM architecture was proposed and reviewed several times and was finally cancelled in favor of building everything with million instructions per second (MIPS) chips. One of the more famous of these project redirections led to Cutler closing the plant and giving everyone the summer off. Cutler resigned in October of 1988.

In the meantime, the PC wave had broken over Digital. Its responses, famously scattered, came in the form of the DECmate II (another word processor), the Professional 325 and 350, and the Rainbow 100. They did not impress the market and sold miserably, leaving Digital to eventually adopt a PC-clone architecture.

Despite such setbacks, in 1990 the company managed to reach its peak, with more than 120,000 employees and almost $13 billion in sales.

The VAX 11/780 was the product that launched DEC into its final years of growth. Here, Olsen is shown with Gordon Bell, one of the key leaders of the VAX project.

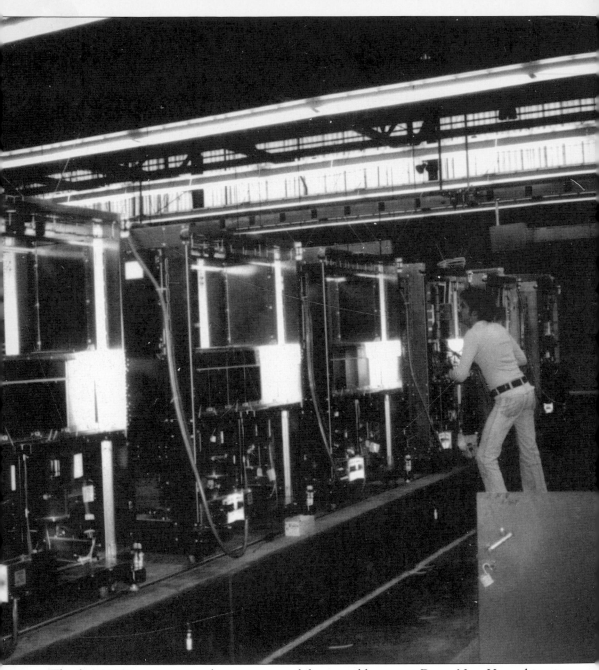

The first VAXes are prepared to move out of the assembly area at Derry, New Hampshire, in this shot from November 11, 1977. The VAX was such a hit that it sustained Digital's fortunes through the 1980s and beyond, insulating it for a time from the PC revolution. Its companion software, VMS (now called OpenVMS), still has numerous adherents, and it was reputed to be the inspiration for many of the features in Microsoft's Windows NT operating system.

This photograph shows the VAX inspection operations.

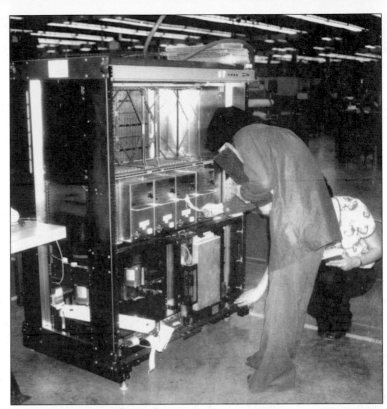

Here we see the VAX test area at the Derry facility.

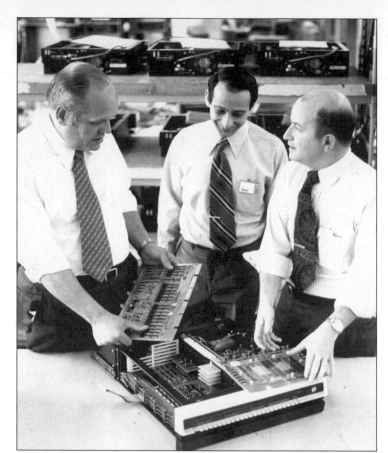

Olsen liked to get his hands on things. Here, he is shown with an unidentified manager and Andy Knowles.

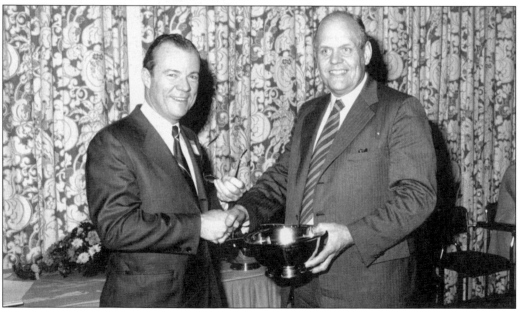

Win Hindle is seen with Ken Olsen at a company dinner held in 1978 to celebrate DEC's 20th anniversary.

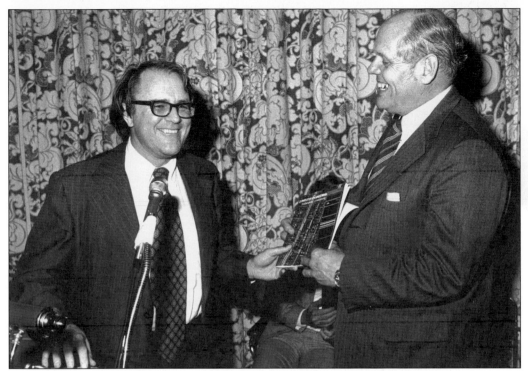

Gordon Bell is shown here on the same occasion.

In a lighter moment, a few years later, Olsen smiles with Jack Smith at the 1981 Maynard Modules Christmas party. The badge worn by Smith reads, "Maynard Plant Modules—Mill Transporter, the only way to fly."

Olsen was often courted by politicians, especially in the years of the "Massachusetts Miracle," when the state's economy rebounded and DEC and its minicomputer rivals reached the apogee of their fortunes. Here, Massachusetts governor Michael Dukakis, in his second term, presses the flesh. The photograph, from Olsen's personal collection, was signed by the governor, "With much appreciation."

Olsen appears in this c. 1970s photograph with MIT president Jerome Weisner.

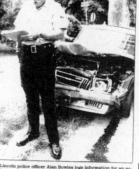

An ugly incident marred Olsen's personal life in 1983. Sgt. Marc E. McDonnell, from nearby Fort Devens, attempted to extort $1.25 million from Olsen. The Green Beret claimed to represent a paramilitary terror group and threatened to kill Olsen. Part of the plot involved blowing up a utility pole near Olsen's home, as shown on the front page of this issue of the *Concord Journal* newspaper. This image is from Olsen's own copy of the paper.

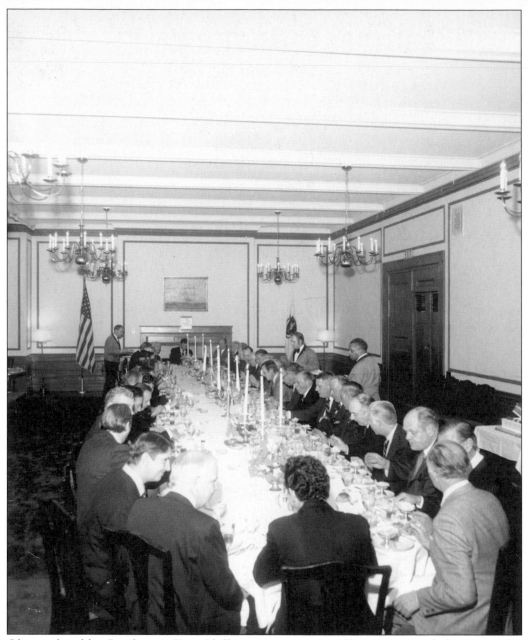

Olsen, who, like Raytheon's Tom Phillips, was an active Christian, joined the Rev. Billy Graham at a prayer breakfast, probably in Washington, D.C. Olsen is toward the right in the foreground.

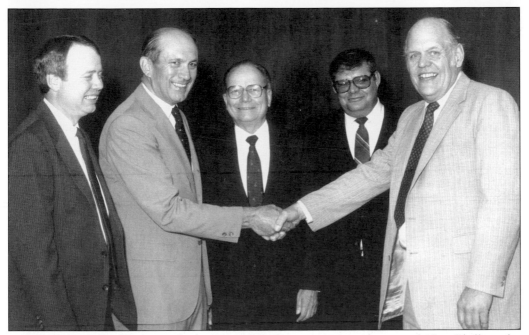

In this photograph, Olsen ties the knot—at least for one joint product—with Tom Phillips, the CEO of Raytheon. The latter firm agreed to make hardened militarized versions of the PDP-11 for use in defense and aerospace applications.

Andy Knowles and Jack Smith are shown here in conversation.

A race car co-sponsored by Digital is shown in the shop in this 1980s photograph.

The Detroit Grand Prix is in progress here. A Digital-sponsored car can be seen in the distance.

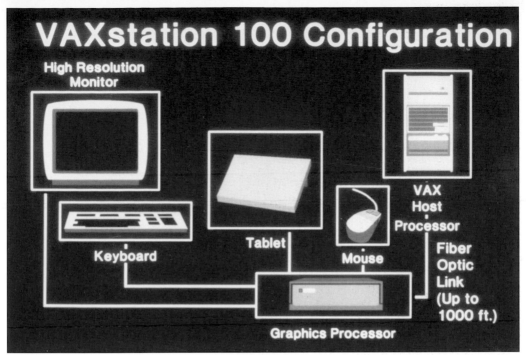

VAXstation 100 Configuration

High Resolution Monitor

Keyboard

Tablet

Mouse

VAX Host Processor

Fiber Optic Link (Up to 1000 ft.)

Graphics Processor

This is a functional diagram of the VAXstation 100, one of DEC's entries in the burgeoning engineering workstation market and a spin-off of the original product line.

This publicity shot demonstrates a tablet system for digitizing data.

Another publicity shot demonstrates an early WYSIWYG display system.

This photograph displays the complete VAXstation system.

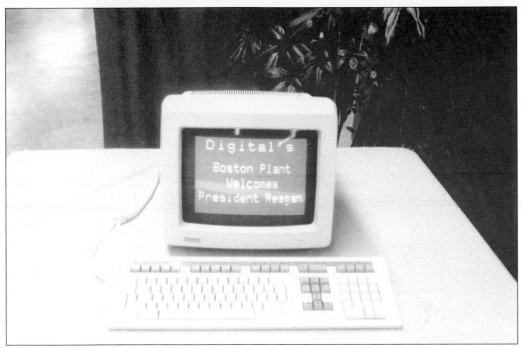

In its glory days, DEC was considered the right place for President Reagan to be seen.

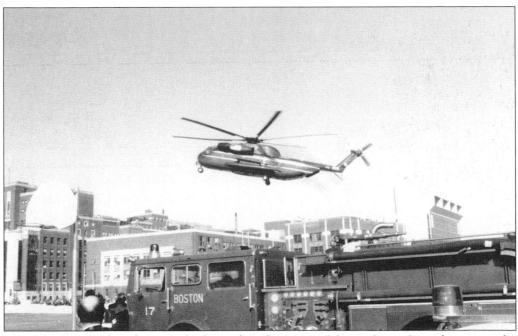

This snapshot catches the arrival of President Reagan on *Marine Corps One* adjacent to the DEC Boston plant.

Police came out in force to provide crowd control along Boston's streets during President Reagan's visit.

Motorcycles, mounted police, and police cruisers helped ensure a smooth arrival for Reagan. Some members of the crowd can be seen holding protest banners.

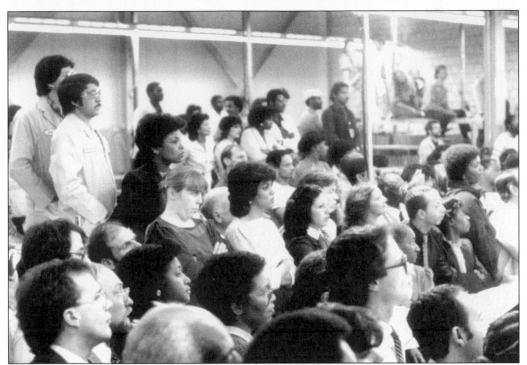

Employees of the Boston plant listen to the two presidents, Regan and Olsen.

Jack Smith and Ken Olsen are shown here with President Reagan.

In this photograph, Olsen and Reagan share the spotlight.

Olsen chatted with local managers prior to the president's arrival.

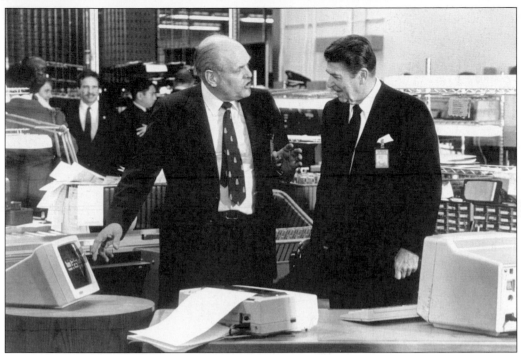

Olsen explains the wonders of computing to "the Gipper."

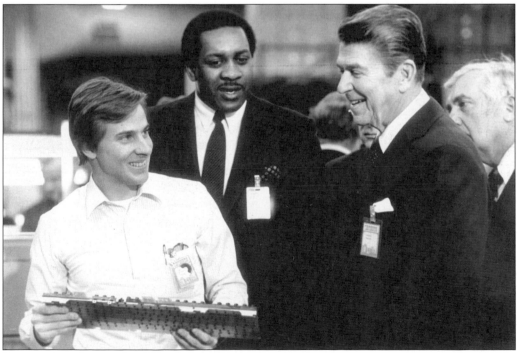

Reagan chats here with a Digital employee.

Boston plant workers are seen here awaiting President Reagan.

The DEC Industrial 14/30 Controller was part of the growing industrial automation sector that was one of the last areas to be eroded by the PC onslaught.

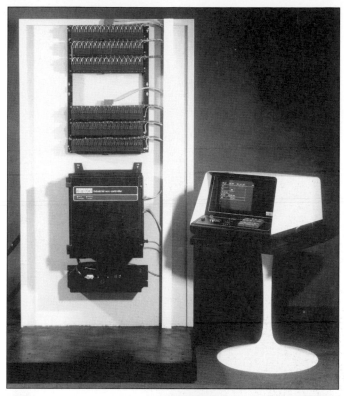

Digital was one of the pioneers, in this case with the VAXstation 100, of the vertical desk-side configuration. According to one company legend, Olsen tested out this vertical configuration by sitting on a cabinet to make sure it was built for real-world use.

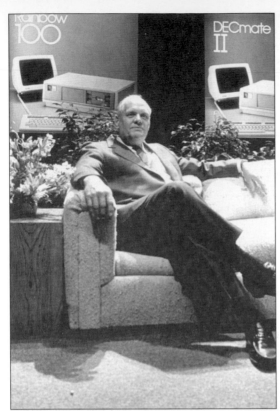

Here, Olsen is shown at ease prior to the teleconference at the Boston Park Plaza Hotel introducing DEC's multipronged response to the PC threat.

An unidentified executive gets made up for the teleconference.

Another executive, Andy Knowles, receives the same treatment.

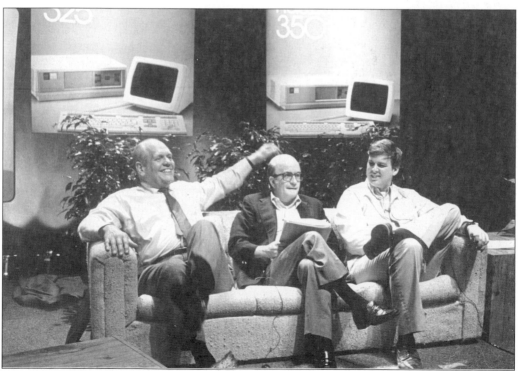

Olsen, Knowles, and an unidentified executive are shown here just before showtime.

Despite the company's best efforts, DEC's PC response received a cold reception from the market, which had already anointed IBM and its compatible brethren as the kings of the desktop market.

Olsen is shown here during a visit with Ilene Jacobs, seen on the right, and the internal School of Marketing c. 1986.

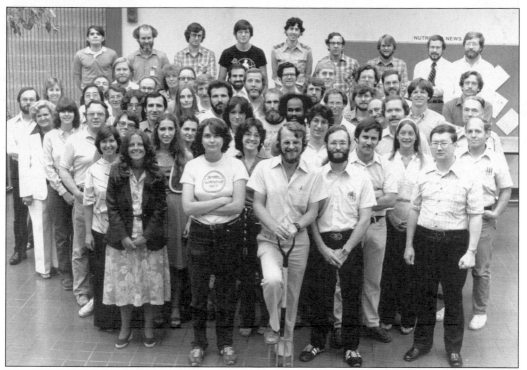

This VMS V2 team photograph was taken in 1979 at the Tewksbury, Massachusetts, site. (Photograph courtesy of Benn Shreiber.)

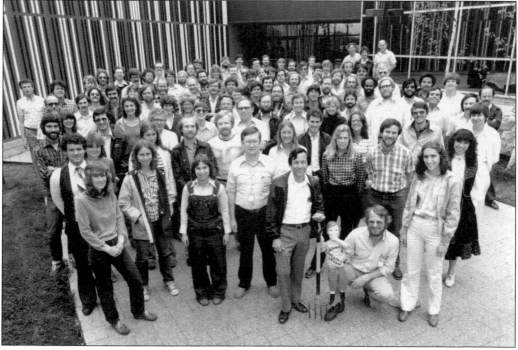

In another team photograph, the VMS V3 team is shown in 1982 outside of the Spitbrook Road site in Nashua, New Hampshire. (Photograph courtesy of Benn Shreiber.)

Here is a glimpse inside a Woods Meeting, one of the famous off-site management "confabs" at

which DEC's strategic directions were determined.

In November 1985, Olsen, who is of Swedish ancestry, hosted a visit from the Swedish Council of America.

This photograph shows the dedication of the Greenville, South Carolina printed wiring board facility in August 1982.

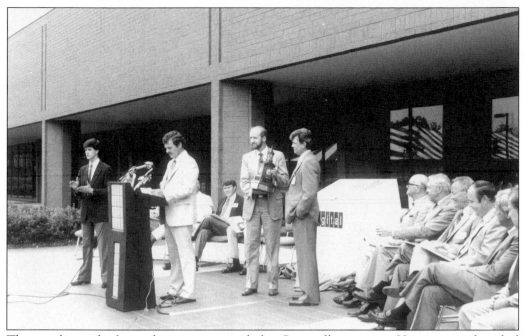

The usual round of speeches accompanied the Greenville opening. Here, an unidentified executive holds a scale model of the mill clock tower from atop the mill complex in Maynard.

As seen here, equipment demonstrations and television cameras accompanied the Greenville dedication.

During the dedication, this unidentified employee was photographed outside of the surface test department.

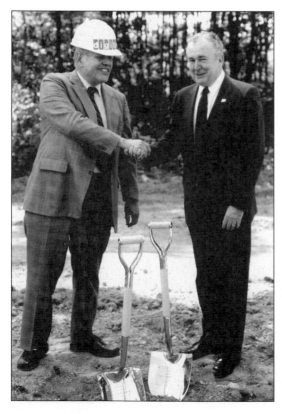

Olsen and Connecticut governor William A. O'Neil are shown here at the groundbreaking for the Enfield, Connecticut, plant in late 1983.

Another view from the Enfield groundbreaking shows an unidentified man, Olsen, Governor O'Neil, and plant manager Bruce Dillingham.

DECtown and its more lavish successor, DECworld, provided the ultimate publicity splash for DEC and helped sustain excitement for the company's products, even as market forces were eroding DEC's leadership. Here, H. Hamada, CEO of Ricoh, is shown at the Corporate Leaders Forum of the 1987 DECworld.

This is one of Digital's women's soccer teams in the mid-1980s. Third from the left in the back row is Fidelma Hayes Russo, a manager who later became a vice president at Data General. The second person from the right in the back row is Niamh Darcy. In the front row, third from the left, is Pippa Jollie; to the right of Jollie are Annette Lee (not a DEC employee) and Rachel Berman. The other women in this photograph are unidentified. Berman's dog, Sassy, is in front of the group. Sassy's name was recorded in the network name of several computers at DEC: SASVAX, SASS, and AXPSAS. (Photograph courtesy of Rachel Berman.)

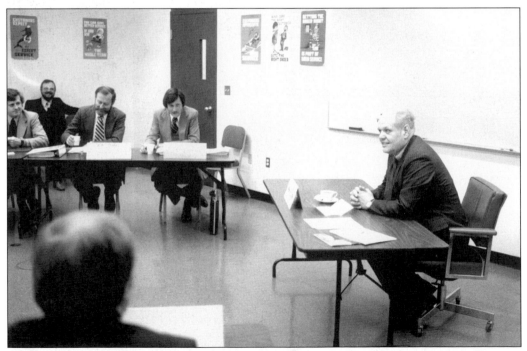

Olsen and a group of executives are shown here under a row of exhortatory posters. The date and location of the photograph are unknown.

April 19, 1983, the Massachusetts Patriots Day holiday, was also Ken Olsen Day in Maynard. This is the official program for the day's events, which included a parade and a formal dinner. The event followed the celebration of the company's 25th anniversary.

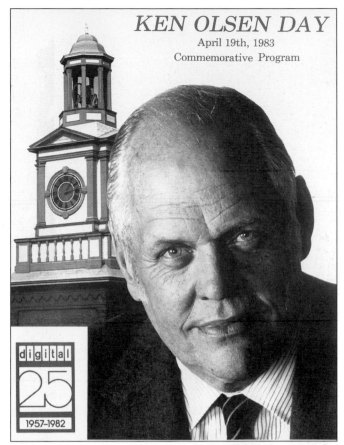

Ken Olsen is seen here examining 25th anniversary greetings from around the world.

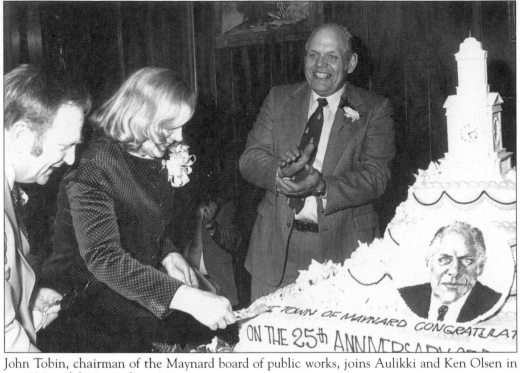

John Tobin, chairman of the Maynard board of public works, joins Aulikki and Ken Olsen in cutting an elaborate cake.

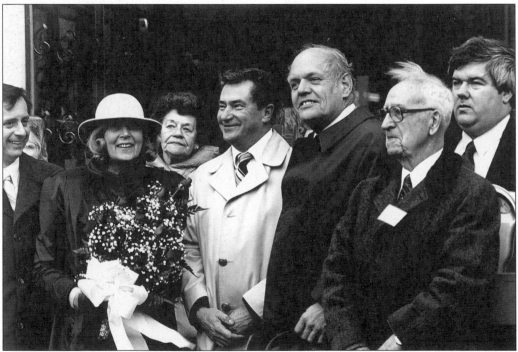

Aulikki and Ken Olsen flank Bob Gilligan of the Maynard board of selectman during an outdoor portion of the Ken Olsen Day celebration.

Ken Olsen laughs as former Massachusetts governor Ed King delivers his remarks.

No Patriot's Day celebration in Massachusetts—even when it is also the Ken Olsen Day parade—is complete without local Revolutionary War reenactors.

Ken and Aulikki Olsen were chauffeured in a flag-draped vintage car.

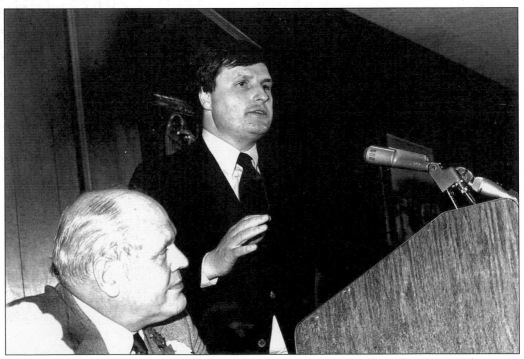

State senator (later congressman) Chester Atkins participated in the Ken Olsen Day celebration.

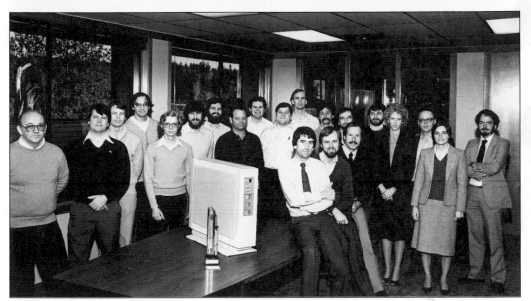

DECWest, in Washington State, became a key design center in the 1980s. Pictured, from left to right, are the following: Larry Coppenrath, Peter Schnorr, Daryl Havens, John Parchem, Bruce Butts, Rob Short, Ken Abramson, David Cutler, Kris Barker, Myles Connors , Jay Palmer (rear), Roger Heinen (rear), John Balciunas (rear), Len Kawell, Angeline Leathers, Don MacLaren, Kate O'Shea, and Tom Diaz. Seated in front are Ken Western, Kim Peterson, and Reid Brown. (Photograph courtesy of Reid Brown.)

The DECWest Management Team included, from left to right, the following: Larry Coppenrath, hardware; Roger Heinen, software; Reid Brown, product management; and David Cutler, DECWest general manager. (Photograph courtesy of Reid Brown.)

MicroVAX I, one of the fruits of DECWest, is shown here with Bill "B. J." Johnson, Digital vice president of engineering. (Photograph courtesy of Reid Brown.)

In 1983, MicroVAX I received the product of the year award from *Electronic Products* magazine. David Cutler, MicroVAX I manager and lead engineer (left) is shown here with B. J. Johnson. (Photograph courtesy of Reid Brown.)

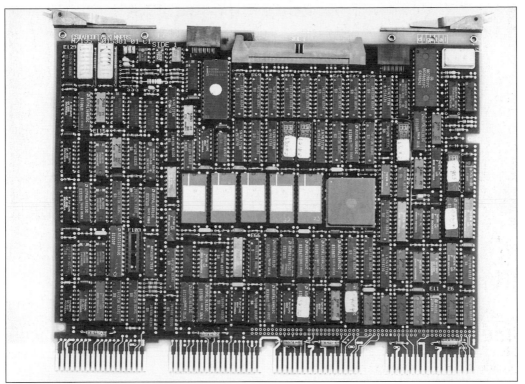

This photograph shows a MicroVAX I CPU module. (Photograph courtesy of Reid Brown.)

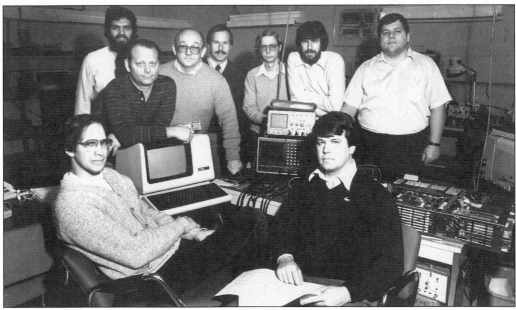

The MicroVAX I hardware engineers and managers included, from left to right, the following: (seated) John Parchem and Peter Schnorr; (standing) Ken Abramson, David Cutler, Larry Coppenrath, Reid Brown, Bruce Butts, Rob Short, and Myles Connors. (Photograph courtesy of Reid Brown.)

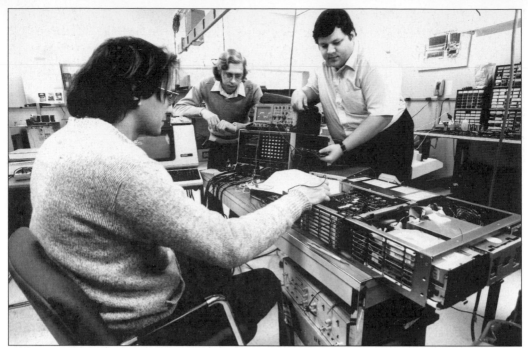

MicroVAX I hardware engineers are shown at work in the hardware lab. They are, from left to right, John Parchem, Bruce Butts, and Myles Connors. (Photograph courtesy of Reid Brown.)

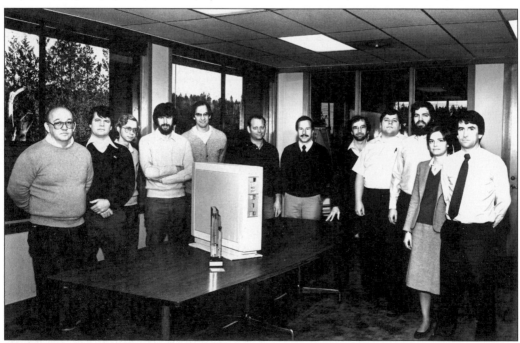

MicroVAX I hardware engineers, diagnostic staff, technical writers, and managers are shown in this image. They are, from left to right, as follows: Larry Coppenrath, Peter Schnorr, Bruce Butts, Rob Short, John Parchem, David Cutler, Reid Brown, John Balciunas, Myles Connors, Ken Abramson, Kate O'Shea, and Ken Western. (Photograph courtesy of Reid Brown.)

The MicroVAX I product of the year award for 1983 was bestowed by *Electronic Products* magazine. David Cutler, MicroVAX I manager and lead engineer, receives the award from Steve Weitzner, editor-in-chief of *Electronic Products* magazine. (Photograph courtesy of Reid Brown.)

MIT Professor Jay Forrester, a longtime DEC board member, is shown here at the 1985 Inventor's Hall of Fame induction ceremony held at Anthony's Pier Four Restaurant in Boston. Forrester developed the original magnetic core memory that greatly improved the capabilities of computers until solid-state memory became technically feasible and affordable. (Photograph by Karen McCarthy.)

Ann Jenkins, Olsen's longtime assistant, is shown here with General Doriot *c.* the early 1980s.

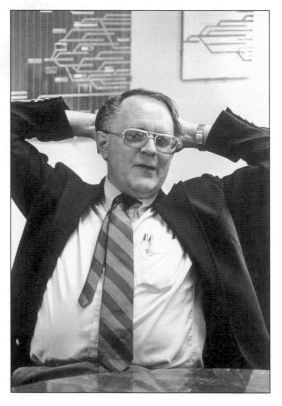

Gordon Bell is pictured here at an academic computing conference held at the University of Lowell in 1984, one year after he left DEC. (Photograph by Karen McCarthy.)

Five

DIGITAL DENOUEMENT

As Digital's fortunes peaked, it was hard not to get caught up in the enthusiasm. Digital was truly a big business, and its future looked rosy. But those expectations dissipated rapidly as it became clear that with competing products, drooping profitability, and a confused direction, the company was not really in control of its destiny.

Finally, in 1992, the unthinkable happened: Ken Olsen resigned. In his place came Robert Palmer, a much younger and less experienced executive from the company's chip operation. Palmer's personality and style was dramatically different from Olsen's. Symbolically, Palmer broke with the past by moving headquarter operations out of the old mill and into more modern facilities a few miles away. Fundamentally, the corporate culture changed little.

Olsen, for his part, set out to launch a new computer company, Modular Computer Systems, which lasted several more years but ultimately faded away—but not before his place of honor in the industry's history was repeatedly assured by awards and magazine articles.

Technically, despite its obvious problems, DEC continued to advance.

After Dave Cutler went to Microsoft in 1988 to create Windows NT, DECwest drifted. The hardware mission was ended, but DECwest's work continued with a Unix software focus.

Still, according to Reid Brown, over 90 percent of the scalar PRISM architecture was reborn in the much-admired Alpha architecture. According to Brown, after Microsoft released Windows NT, Benn Schreiber, a software engineer who had worked under Cutler, proposed that DECwest work with Microsoft to support Windows NT on the Alpha architecture. Schreiber put together a team that successfully ported Windows to Alpha and released it back to Microsoft. Brown says that Schreiber still has the autographed $100 dollar bill from Cutler betting him that he could not do it.

Unix work continued at Digital as well, particularly as that operating system grew in popularity. And the company's storage products group remained an important force in the industry.

DEC even made a mark on the emerging world of the Internet. It was the first member of the Fortune 500 to have a Web site. For a time, Digital's AltaVista search service offered extremely fast and comprehensive results and claimed to have the most comprehensive indexing of the Web. It was the top-rated search engine in many computing industry and user reviews, and it won numerous awards, including the CeBIT 1996 Web site of the year, *Internet World* magazine's 1996 industry award for outstanding service, and the 1996 CNET award for best Internet tool.

Finally, in 1998, DEC succumbed to the seductions of PC giant Compaq. Today, what's left of Digital is merged deep within California-based Hewlett-Packard, which itself acquired Compaq in 2002.

Edgar H. Schein, the principal author of the 2003 book *DEC is Dead: Long Live DEC* and a Sloan Fellows professor emeritus of management at the Sloan School of MIT, consulted for DEC from 1966 to 1992. Fellow authors Peter S. DeLisi and Paul J. Kampas are both consultants with academic connections, the former at Santa Clara University and the latter at Boston College. Michael M. Sonduck is president of a management consulting firm.

In *DEC is Dead: Long Live DEC*, the authors examine the legacy of Digital. In their view, much of the story revolves around the creation of Digital as a modern, research-based corporation inspired by, and in many ways modeled after, the ways of the research university. DEC, for example, largely eschewed a hierarchical structure. Though it had this and most other typical business functions, they were submerged in a larger culture where employees were more or less collegial equals. Unlike most businesses, say the authors, DEC did not function by command, but by consensus: consensus among individuals and between groups, and consensus among managers. Even the ultimate consumers of the company's products were often part of a consensus-reaching process. Schein cites a few simple and oft-articulated corporate values, mostly the product of founder Ken Olsen, as one of the few constraints on this experiment in democracy. Indeed, Olsen himself often acted as an observer as well as a participant in management, occasionally playing the Socratic goad to his immediate reporters—indirectly pushing them to resolve key points under discussion.

In good times, particularly as Digital was pioneering wholly new ways of designing, manufacturing, selling, and supporting computers, this time-consuming and rigorous process of arguing out and negotiating every detail yielded good results. Where there was no clear road map to the future, this tentative, lurching, and always fact-based process proved itself valuable. The company's products were widely admired, customers were fiercely loyal, and DEC employees became a kind of subculture within the larger fabric of business. They came to think differently from others and came to see no reason to ever change. In particular, though, says Schein, if one were to make an analogy to the inherent characteristics of a living thing, Digital lacked the money gene: money was always a by-product of doing things well, not the primary focus of the organization. Thus, when competition grew red-hot across the spectrum in the 1980s and 1990s, Digital simply couldn't adapt.

That, alas, is the point of the book and the key to its title. DEC died—but much of DEC's culture has lived on. In its heyday, DEC influenced the thinking behind many other startups, and since its decline began, DEC alumni have made their presence felt around the globe.

To be sure, a fair number of the old Digital buildings—some now sporting HP signs—still dot the landscape of Massachusetts, New Hampshire, and elsewhere, but only a fraction of the former employees are still there. Similarly, the DECwest building still exists as an HP sales office and engineering support facility, but only a few Digital survivors remain.

In short, DEC exists as history and as a shared memory, perhaps even a shared ideal, among thousands of company veterans. But the strange synergy that made DEC a special place for more than 40 years is gone.

This snapshot shows Olsen on a visit to the Naval Postgraduate School in Monterey, California in April 1986—a visit that helped clinch a $25 million sale, according to a memo by sales representative Bill Coles.

Olsen was honored for his contribution to computer science by the Foundation for the National Medals of Science and Technology.

Olsen and Computer Museum director Oliver Strimpel are shown here in conversation in 1994.

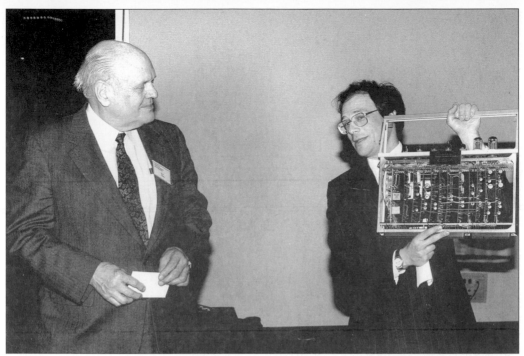

Olsen and Strimpel are shown with a circuit assembly from an early pre-Digital computer, probably the Air Force SAGE air defense computer.

Olsen hosted a Take Your Daughter to Work Day at Modular Computer, the company he launched after leaving Digital.

A CAHNERS PUBLICATION

NOVEMBER 1996

Electronic Business Today™

THE BUSINESS MAGAZINE FOR THE EOEM MANAGER

Digital's Alpha Bet

page 34

Robert Palmer,
Digital's
chairman
and CEO.

**High demand halts
DRAM price slump**
page 45

**Benchmark your way
to a better business**
page 57

Digital received new leadership in 1992 with the appointment of Robert Palmer, from DEC's semiconductor operation, to lead the company. The cover story, written by the author in 1996, focused on DEC's technically outstanding Alpha technology.

The movie was a gigahit, indeed. One of the last big splashes Digital made before getting absorbed by Compaq was having some of its fast Alpha-based computers render images for the hit movie *Titanic*. The company did its best to ride the coattails of the Hollywood hit. (Image courtesy of Paul Delvy.)

Tru
Op
Wir

Introducing Com
For the fastest en

COMPAQ
Better answers

Compaq kept Alpha in its lineup after acquiring Digital in 1998 and maintained some elements of the status quo within the company. But many things changed, too. For instance,

DEC's Unix teams were cut sharply, and decision making was centralized in Houston. (Image courtesy of Paul Delvy.)

DEC Is Dead, Long Live DEC

Lessons on Innovation, Technology, and the Business Gene

The Lasting Legacy

of Digital Equipment

Corporation

EDGAR H. SCHEIN

with **PETER S. DeLISI, PAUL J. KAMPAS,**
and **MICHAEL M. SONDUCK**

DEC is dead, but some still see its presence in the industry. Edgar Schein's 2003 book put a spotlight on Digital's place in history and argued forcefully that DEC's influences continue to permeate much of the high-tech industry.